IMAGES
of America
BANDON

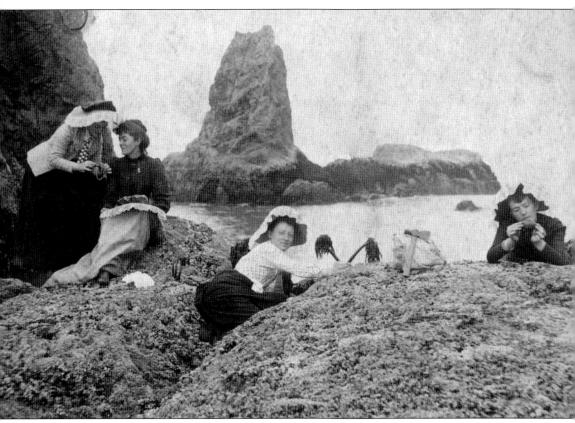

A WEALTH OF HISTORIC IMAGES. The Bandon Historical Society was founded in 1976 to preserve and document the history of Bandon and the Coquille Valley and to share this heritage with future generations. The Bandon Museum is now located in Bandon's former city hall on Highway 101, which was one of the first buildings erected after the devastating fire of 1936. (Courtesy Bandon Historical Society.)

ON THE COVER: Charles Wesley Andrews (1875–1950), a noted Oregon coast photographer, captured this serene image of two women relaxing on the bluff overlooking the Bandon bar. The Coquille River Lighthouse, constructed in 1899 and decommissioned in 1939, is featured on the logos of both the Port of Bandon and the City of Bandon, and may be thought of as a symbol for Bandon's golden age. (Courtesy Oregon Historical Society.)

Images of America
BANDON

Robert Miller and Reg Pullen
with the Bandon Historical Society

Copyright © 2013 by Robert Miller and Reg Pullen with the Bandon Historical Society
ISBN 978-0-7385-9661-7

Published by Arcadia Publishing
Charleston, South Carolina

Printed in the United States of America

Library of Congress Control Number: 2012947321

For all general information, please contact Arcadia Publishing:
Telephone 843-853-2070
Fax 843-853-0044
E-mail sales@arcadiapublishing.com
For customer service and orders:
Toll-Free 1-888-313-2665

Visit us on the Internet at www.arcadiapublishing.com

To the men and women who find Bandon and leave it a better place

Contents

Foreword		6
Acknowledgments		7
Introduction		8
1.	Nasomah	9
2.	A Canal Gives Birth to Bandon	23
3.	Jetties, Life-Saving, and the Lighthouse	33
4.	The Golden Age	45
5.	A Spirit Unbroken	59
6.	Timber, Logging, and Lumber	71
7.	Cranberries	83
8.	Dairy and Cheese	95
9.	Recreation, Attractions, and Celebration	107
10.	World-Class Golf Comes to Bandon	121
Bibliography		127

Foreword

As a Bandon native and four-term mayor, I am proud to have been asked to write the opening words for this important book chronicling, in photographs, Bandon's colorful and varied history.

Not only have I lived here for more than 70 years and witnessed the tremendous reformation of our beautiful beachside community, but my mother, who is nearly 96 years old, was also born in Bandon. Many of the photographs in this book will bring back memories for her. She was a teenager before the devastating fire of 1936 and remembers well many of the scenes that this book preserves.

When the fire hit Bandon, my grandfather was the owner and publisher of the *Western World* newspaper. He and my grandmother were spending the weekend in Florence, Oregon, and it took him three days to get back to Bandon, where they found their home destroyed and their newspaper business severely damaged. Undaunted, my grandfather and the other leaders of the community worked tirelessly to restore the community that they loved, and today, it is the jewel of the Oregon coast.

The Christmas after the fire, my grandfather wrote a poem to share with his *Western World* readers that summed up what everyone was feeling. It is too long to share in its entirety, but here is the ending:

> It's the day before Christmas,
> In a shack-sheltered town,
> But you can't find a grumble,
> Nor a sneer, nor a frown.
> Fate's unkindness has left us laid low for a day,
> But we love the old homesite; and here we shall stay.
> So let's raise our voices in song and in praise;
> All hail to New Bandon, The dream of our days.

That is the Bandon that so many have come to know and love today. People feel welcome here—and with good reason. Our population is comprised of a wonderful mix of old-timers and newcomers who have united to make Bandon the community it is today.

Special thanks go to the authors, Robert Miller and Reg Pullen, who, along with assistance from one of Bandon's greatest treasures, the Bandon Historical Society, are preserving the history of our beloved town.

—Mayor Mary Schamehorn

Acknowledgments

This volume is intended to inspire an interest in the color and sweep of Bandon history, rather than to serve as a comprehensive treatment of the subject. We hope you will visit the Bandon Historical Museum and discover the many fine writers who have covered this topic in greater depth.

We thank the Bandon Historical Society and its people—executive director Judy Knox, the board of directors, the volunteers, and supporting members—who give so generously of their time and talents to preserve the past for the edification of future generations. We are grateful for their advice, information, and support in the writing of this volume.

We thank Hannah Cooney of the Coos Historical & Maritime Museum and Scott Rook of the Oregon Historical Society for their able and efficient help in preparing this volume. We thank Mary Schamehorn for her foreword and for her longtime distinguished service as the mayor of Bandon. We thank and recognize Brenda Meade, Sharon Parrish, members of the Coquille Indian Tribe Culture Committee, and Prof. Mark Tveskov for advice and criticism on the first chapter. We thank our contributing writers Geneva Miller, Christina I. Shaw, Joe Sinko, and John Ohanesian.

Throughout the book, we credit numerous contributors of images, and we reiterate our gratitude for their willingness to share them. We thank Steve and Margaret Pounder and the staff of the Bandon Coffee Café for the hours spent under their watch while editing this volume. Finally, we thank our Arcadia Publishing editors, Jared Nelson and Sara Miller, for their wisdom, encouragement, and careful shepherding of this book to completion.

Responsibility for errors rests with the authors alone, and we hope you will contact us with your corrections, amplifications, and suggestions for further research. We also hope you will consider donating your family photographs and artifacts to the Bandon Historical Society so that they may be preserved and appreciated by others.

—Robert Miller and Reg Pullen

Introduction

The hills at Bandon rise serene
 Against the morning sky
Beyond the valley, far and green,
 Where wooded lowlands lie;
The wind with weird and age-old runes
 Goes crooning up the beach
And heaps the shifting, rolling dunes
 Beyond the breakers' reach.

Grim sentinels of cypress lift
 Their gnarled and twisted forms
Above the wreckage and the drift,
 Defying wind and storms;
Across the broad Pacific breast
 The lazy ships drift by
And in the dim, mysterious west
 The flaming sunsets die.

What galleons in the days of old
 Have sought these silent lands
What argosies with wealth untold
 Are buried in these sands;
How ceaselessly the breakers roll,
 How mournfully they weep
As solemnly they chant and toll
 The requiems of the deep.

Beyond the grey, uncertain years
 The future holds in store.
What argosies of hopes and fears
 May reach this sounding shore;
What galleons of golden dreams
 May sail the surging sea
And come to rest in placid streams
 At Bandon-by-the-Sea.

("Seashore" by Bob Pressley, published by *Western World*, March 1925.)

One

NASOMAH

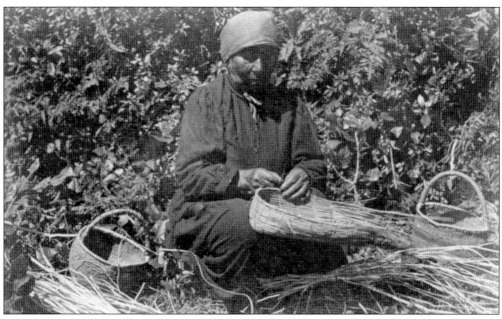

BASKETRY AT THE CREATION. A Coos-Coquille creation myth tells how the creator made the world by piling layers of blue earth on the waters. The tides kept swamping the land, so the people laid down strips of basketry to stem the flow. In time, the basketry became the sands along the beaches. Here, Nellie Lane, the daughter of a Nasomah headman, weaves a basket. (Courtesy Oregon Historical Society.)

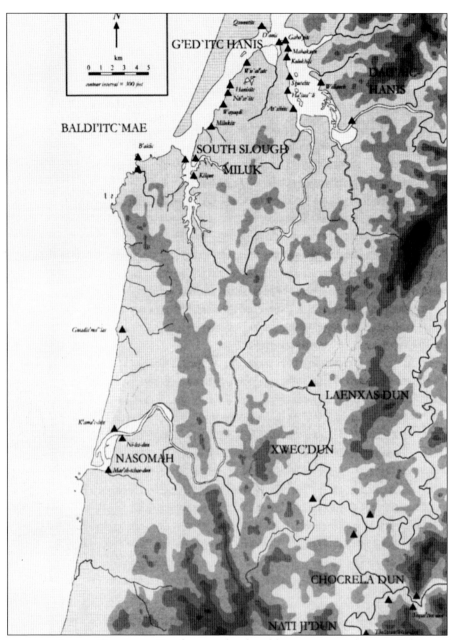

PEOPLE OF THE LOWER COQUILLE. Bandon may be the oldest continuously occupied townsite in Oregon. "Nasomah" is understood to be the word for the people living along the lower Coquille River. The Nasomah had several permanent village sites around the mouth of the river, but they also maintained camps on the coast for harvesting shellfish and seaweed and hunting sea mammals, as well as camps upriver for fishing, hunting elk, and harvesting plants. Over the course of thousands of years, the Nasomah survived earthquakes, tsunamis, and epidemic diseases introduced by Hudson's Bay Company fur trappers. By 1856, however, most of the remaining Nasomah had been killed by soldiers and settlers or removed to reservations, their "lifeways" extinguished. Descendants of surviving Nasomah and people of related village groups are now organized as the Coquille Indian Tribe. (Courtesy Prof. Mark Tveskov.)

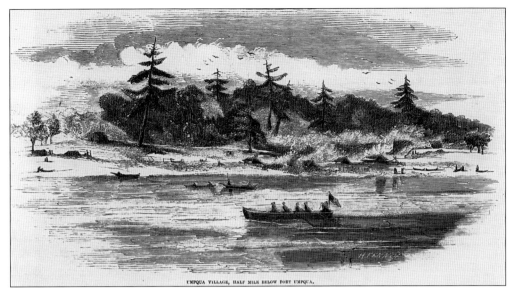

COASTAL PLANK HOUSES. Permanent Nasomah villages consisted of timbered and planked houses in which several family members lived, while smaller dwellings nearby might be used for storage, sleeping, or special activities. No such original structures survive, but this contemporary engraving from the Umpqua River Basin is illustrative. (Courtesy Oregon Historical Society.)

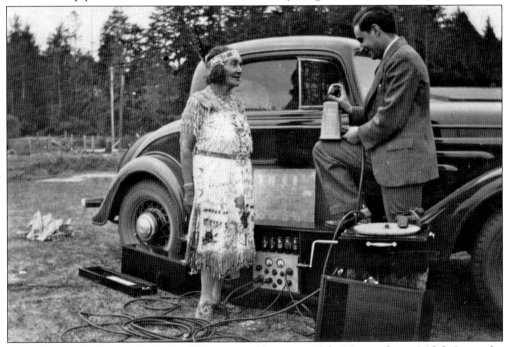

MILUK, THE NASOMAH LANGUAGE. The principal language of the Nasomah was Miluk. Later, the Nasomah used the trade language called Chinook Jargon ("Chinuk Wawa"). This photograph shows Annie Miner Peterson, the last fully fluent speaker of Miluk, recording with anthropologist Melville Jacobs in Charleston, Oregon, in July 1934. The Coquille Indian Tribe now speaks English but is working to revive its ancestral language. (Courtesy University of Washington Special Collections.)

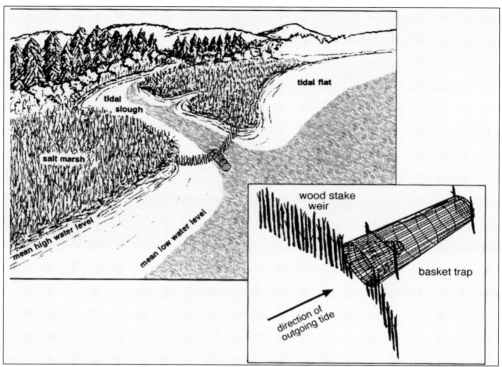

FISHING WEIR TECHNOLOGY. The extensive tidal channels of the Coquille River estuary provided habitats for salmon, herring, smelt, and other fish. Using wooden stakes and woven lattice or basketry, the Nasomah built weirs across the mouths of these tidal channels. Weirs allowed the fish to pass upstream as the tide rose, then trapped the fish as the tide receded. With the use of dugout canoes and dip nets, vast numbers of fish could be harvested. The Nasomah preferred to use hemlock, a durable wood, for the weir stakes; the lower, buried portions tend to be well-preserved and are sometimes visible at low tide, as seen in the image below. (Above, courtesy Prof. Scott Byram; below, courtesy Reg Pullen.)

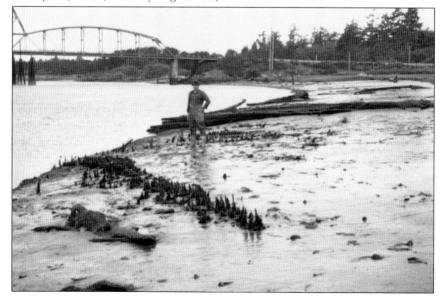

OUTFITTED FOR CLAM-DIGGING. These two unidentified Miluk children from the South Slough are wearing water-resistant cedar bark capes. The digging stick in the hand of the child on the left is probably made from western yew, a wood with high tensile strength. The children are wearing necklaces made from dentalium, a tusk or tooth shell traded from Vancouver Island. The basket cap and collecting basket are made from spruce roots and willow sticks. (Courtesy Bandon Historical Society.)

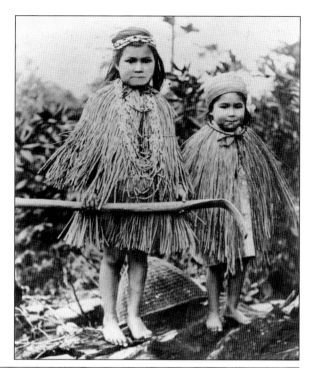

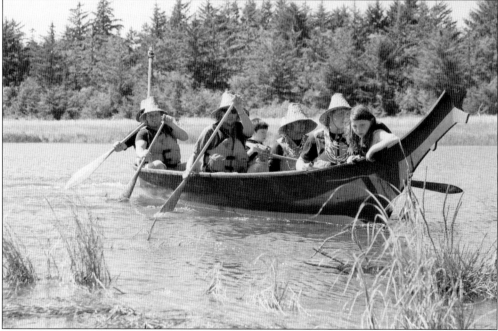

AN OPEN-WATER CANOE. Nasomah canoes typically were shallow dugouts intended for use in estuaries, but the Nasomah may have created larger, open-water craft or acquired them by trade. This *Alu'daq* (a Miluk word for "high-class canoe") has a modern design based upon historical testimony and was built by Applegate Boatworks of Veneta, Oregon. In this 2011 photograph, seven members of the Coquille Indian Tribe paddle into the newly restored Ni-les'tun tidal marsh near Bandon. (Courtesy Roy W. Lowe, US Fish and Wildlife Service.)

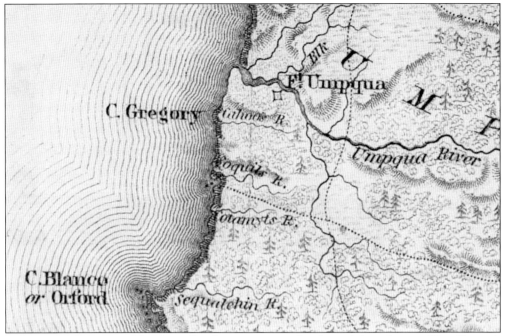

THE EEL IN COQUILLE. The Coquille place name may be derived from "scoquel," a Chinook Jargon word for the Pacific lamprey, an important and distinctive trade commodity from the Coquille watershed. Early maps interpreting this sound variously spelled it as "Shiquits," "Sequits," "Coquette," and "Soquils" (the spelling seen on this 1841 US Exploring Expedition map). The Coquille Indian Tribe prefers to pronounce *Coquille* as "ko-kwel" to honor the native heritage of the name. (Courtesy National Archives at College Park.)

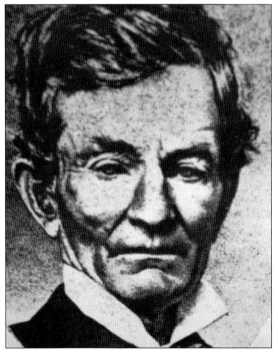

THE 1851 "T'VAULT MASSACRE." In 1851, William Green T'Vault (1806–1869) led an expedition from newly established Port Orford to seek a profitable overland route to the gold mines of Jacksonville, Oregon. Lost and hungry, T'Vault's party circled back to the coast and apparently provoked an attack from the Nasomah. T'Vault survived and ultimately became a speaker for the Oregon Territorial Legislature. (Courtesy Bandon Historical Society.)

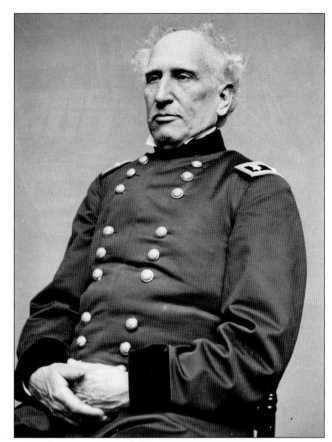

THE CASEY CAMPAIGN OF 1851. Following news of the disastrous T'Vault expedition, Col. Silas Casey (1807–1882) was ordered to lead a punitive expedition against the Nasomah. In the winter of 1851, Casey's three companies of cavalrymen shelled the Nasomah villages and killed 15 Nasomah and destroyed 20 large plank houses, 15 canoes, and 13 tons of dried salmon. Casey later served as a major general in the Civil War. (Courtesy Library of Congress.)

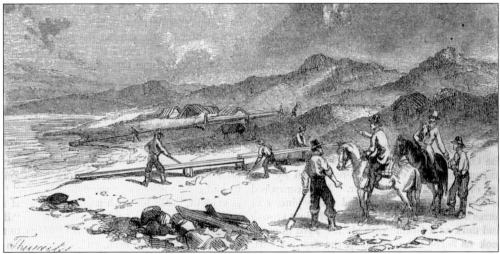

THE GOLD RUSH OF 1853. In the winter of 1852–1853, gold was discovered in the black sands of Whiskey Run, north of present-day Bandon. Within a year, American miners, prospectors, and business speculators had flocked to the region. Many of the newcomers entered into common-law marriages with Indian women. However, tensions between the new settlers and the indigenous population soon escalated into open violence. This drawing from the October 1856 edition of *Harper's New Monthly Magazine* shows men sluicing gold from beach sand. (Courtesy Reg Pullen.)

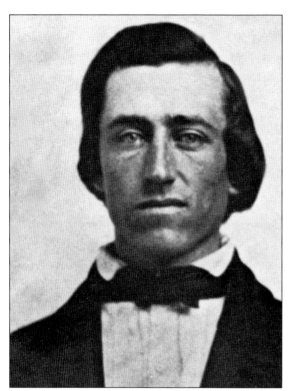

THE 1854 NASOMAH MASSACRE. William Henderson Packwood (1832–1917) worked in packing, mining, and cattle ranching on the Coquille River. In 1854, he helped lead 40 miners in a surprise dawn attack on the villages at the mouth of the Coquille River, killing at least 16 Nasomah. This was denounced as "a most horrid massacre" and "out and out barbarous murder" by F.M. Smith, the sub-Indian agent based in Port Orford, in a letter to Joel Palmer, who was the Superintendent of Indian Affairs for the Oregon Territory. In 1857, Packwood was the youngest delegate at the Oregon Constitutional Convention. (Courtesy Bandon Historical Society.)

NASOMAH COMMUNITY EXTINGUISHED. The Nasomah took little or no part in the Rogue River Wars of 1855–1856, but peacefully surrendered to the government camp in Port Orford. Following abuses at the camp, several Nasomah fled for home. A group of self-styled Port Orford minutemen, including Thompson "Tommy" Lowe (pictured), a Coquille ferry operator, intercepted and killed 15 of these refugees. By July 1856, a majority of the remaining Coos and Coquille Indians had been removed to reservations. (Courtesy Bandon Historical Society.)

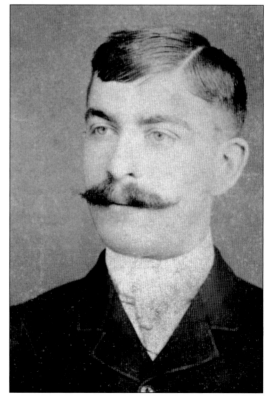

CHARLES NED. Charles Ned (far left) was a Nasomah child who survived the 1854 massacre. A miner's bullet had grazed his head. After the attack, he was taken to live with relatives at South Slough, near Coos Bay. In later years, he married Susan Ned and returned to an allotment near Whisky Run to work and raise his family. (Courtesy Sharon Parrish.)

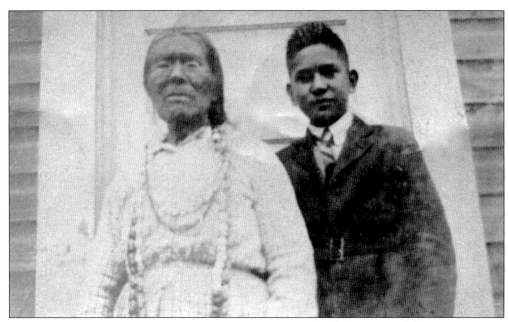

SUSAN NED. Susan Ned (1852–1927) was another Nasomah child who survived the 1854 massacre. She married Charles Ned and bore eight children, at least five of whom survived to maturity. Susan's tales of life on the reservation and her escape back to her own country are movingly recounted in *White Moccasins*, a book written by her granddaughter-in-law, Beverly Ward. Susan is pictured here with her grandson Alfred Mecum. (Courtesy Sharon Parrish.)

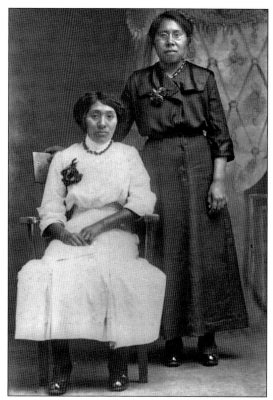

IDA AND MINNIE NED. Ida Belle Ned Mecum (1882–1941) (left) and Minnie Ned (1892–1918) were daughters of Nasomah massacre survivors Charles and Susan Ned. Ida's descendant Brenda Meade, the current chairperson of the Coquille Indian Tribe, has a special interest in cultural preservation and education. (Courtesy Bandon Historical Society.)

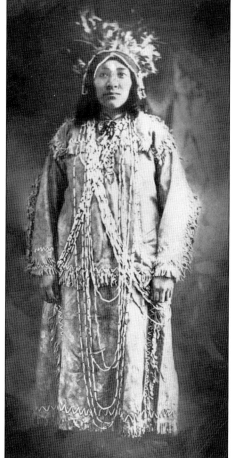

MINNIE NED'S COMING OF AGE. Minnie Ned poses in her puberty ceremony regalia. She is wearing a buckskin dress, dentalium jewelry, and a headdress made of flicker feathers. (Courtesy Bandon Historical Society.)

COQUILLE MARY. Mary (1834–1911), variously called "Gwal'ya," "Hessna," "Coquille Mary," and "Indian Mary," was the daughter of a Nasomah headman and a friend of Susan Ned. Mary was a shaman and a gifted storyteller who kept an unusual diary: a ball wound of rawhide and sinew string along which she fastened various mementos of her life. (Courtesy Bandon Historical Society.)

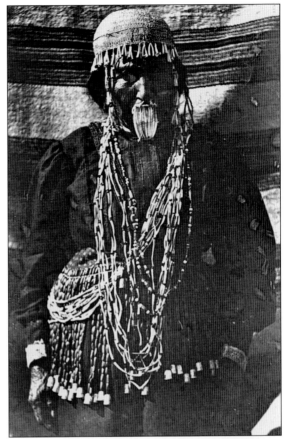

THE KLAKAHMA PAGEANT. Ottilie Parker Kronenberg (1865–1943), daughter of early settler Capt. Judah Parker, delighted in the stories of Coquille Mary, who was her nurse and friend. In 1915–1917, Kronenberg wrote and directed *Klakahma*, a dramatization of Coquille Mary's life story. Kronenberg is also remembered as the popularizer of Coquille Mary's "Legend of Face Rock," an Indian story about one of the most distinctive rock formations off the Bandon coast. (Courtesy Bandon Historical Society.)

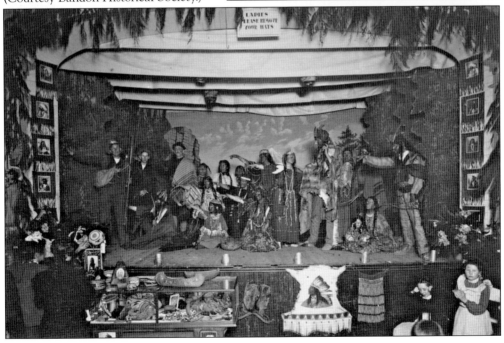

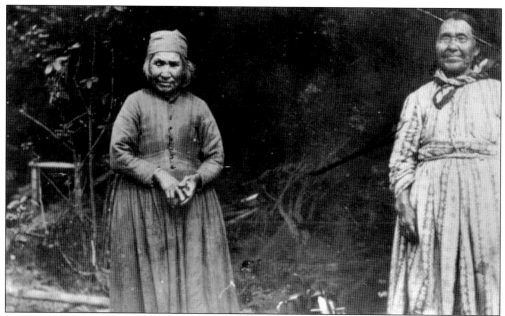

TRIBAL TERMINATION IN 1954. Adulsa "Susan" Wasson (1841–1917), pictured at left above, was an important Coquille Indian Tribe ancestor; Nancy Palmer is the woman at right. Wasson's son, George Bundy Wasson Sr. (1892–1985), became an early leader in the effort to regain lands lost due to broken or unratified treaties. George won a modest cash settlement for tribal members in 1950, but the federal government "terminated" the tribe in 1954. Tribal leaders worked over the following decades to regain federal recognition. In 1988, George's son Wilfred Wasson (1924–1990) testified before Congress: "Instead of vanishing into the melting pot of American obscurity at the time of termination we have grown stronger in our determination to remain Indian." In the 1988 image below, Wilfred Wasson (left) and Linda Mecum meet with US congressman Les AuCoin to discuss restoration of the tribe. (Both courtesy Coquille Indian Tribe.)

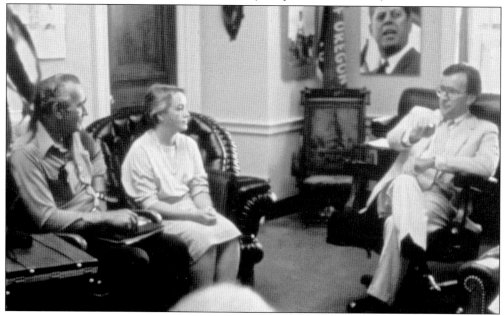

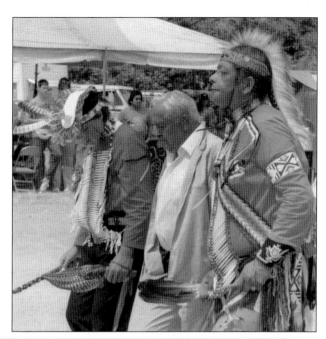

TRIBAL RESTORATION IN 1989. On June 28, 1989, Congress passed the Coquille Restoration Act (Public Law 101-42), which reestablished the Coquille Indian Tribe as a sovereign government and validated the tribe's authority to manage and administer political and legal jurisdiction over its lands and resources, its businesses, and its community members. The first anniversary of restoration was celebrated in Bandon with a traditional salmon bake; in attendance were Fred Murphy (left), Coquille chief Tony Tanner (center), and Sweetwater, a Menominee Indian. (Courtesy John Griffith.)

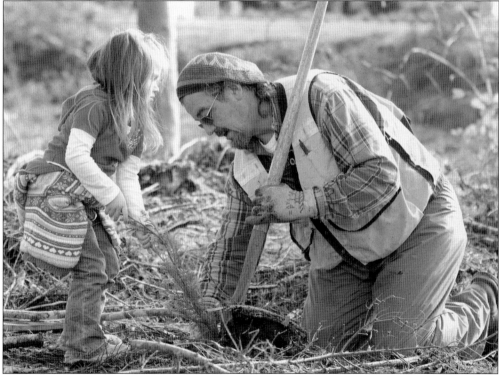

A CONTINUING TRADITION. The tribal government, now headquartered in North Bend, Oregon, strives to ensure the well-being of all tribal members as well as the stability and success of surrounding communities. The tribe manages an economic development corporation, a housing authority, a health clinic, and also sustainably manages over 5,000 acres of forestland. Don Ivy (right) is the tribe's former cultural resources program coordinator. (Courtesy Coquille Indian Tribe.)

BASKETRY—MEMORY MADE TANGIBLE. Myth has it that baskets were present at the creation, and surviving baskets remain one of the strongest and most significant links that Nasomah descendants have to their past. Cooking baskets were made to be watertight and capable of withstanding high heat. Storage and burden baskets varied from large, loosely-woven affairs used for carrying wood to small, finely-woven plates and cups. In this 2006 photograph, Makyra Meade wears a basket cap made of hazel sticks, spruce roots, bear grass, maidenhair fern, and woodwardia. (Courtesy Coquille Indian Tribe.)

Two

A Canal Gives Birth to Bandon

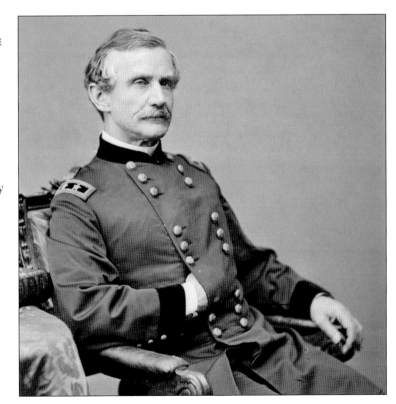

HUMPHREYS AND THE COQUILLE RIVER. Maj. Gen. Andrew A. Humphreys (pictured), chief of the US Army Corps of Engineers, faced a dilemma—the congressional River and Harbor Act of March 3, 1873, clearly called for a "survey or examination of the mouth of the Coquille River, Oregon," but his subordinate, Maj. Nathaniel Michler, did not want to undertake the project. Michler had a much more ambitious plan in mind. (Courtesy Library of Congress.)

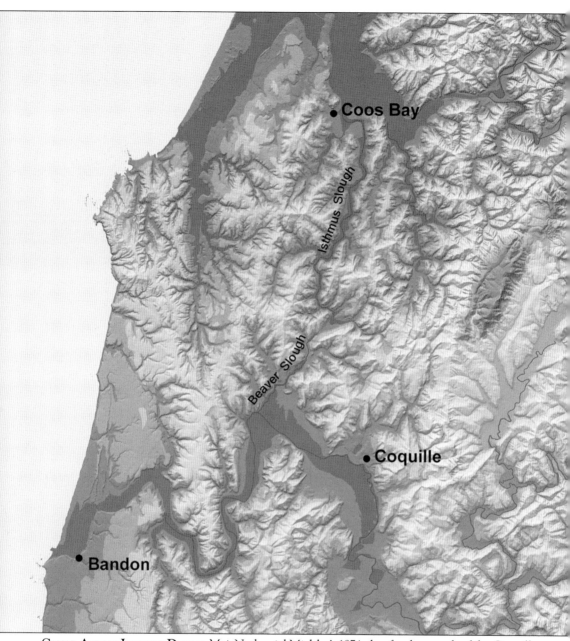

CANAL ACROSS ISTHMUS DIVIDE. Maj. Nathaniel Michler's 1874 plan for the mouth of the Coquille River was to bypass it altogether in favor of a canal 20 miles upstream. A canal made sense on paper—the principal seaport of the region was Empire City, on Coos Bay, which had been exporting timber and coal for the previous 20 years and already had the docks, wharves, warehouses, and commercial infrastructure essential for trade along the Pacific coast. "Bandon," as such, did not yet exist. The Coquille River did not connect with Coos Bay but came tantalizingly close at the "Isthmus Divide" between Beaver Slough (off the Coquille River) and Isthmus Slough (off Coos Bay). If this one mile of separation could be excavated into a workable canal, then the bounty of the Coquille watershed could be barged directly to Empire City for worldwide shipping. (Courtesy Jay Flora, Bureau of Land Management, Coos Bay District.)

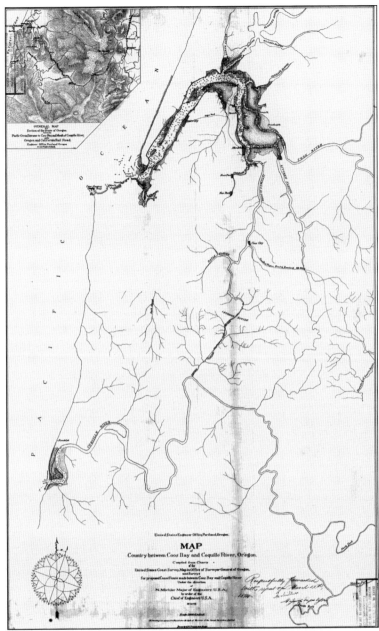

SELLING THE CANAL. Diplomacy was required if the canal project was to be approved. The US Congress had funded a survey for the mouth of the Coquille River, not engineering plans for a canal in the wilds of southwestern Oregon. In a letter to Oregon senator John H. Mitchell, Maj. Gen. A.A. Humphreys tactfully acknowledged the orders, but justified his departure from them as addressing the true "general question . . . a navigable outlet to the Coquille River." In any case, "the difficulties to be overcome and the great cost of any useful improvement of the channel at the mouth of this river, have led the officer in charge to the conclusion that the best outlet to the sea would be secured by the cutting of a canal to connect the river with the waters of Coos Bay." This map of the proposed canal route was signed by Maj. Nathaniel Michler. (Courtesy National Archives.)

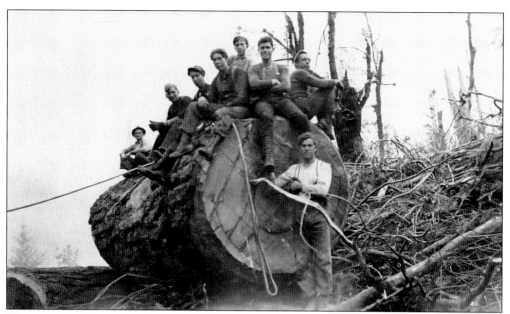

WATER AS THE HIGHWAY. The Coquille Valley was huge, host to 200 farms, and remarkably rich in coal, and precious metals, and timber (as illustrated in the above photograph). However, the region was too mountainous for roads, and the big railroads had not yet reached the area, so the water would have to be the highway. But which way to the sea? (Courtesy Bandon Historical Society.)

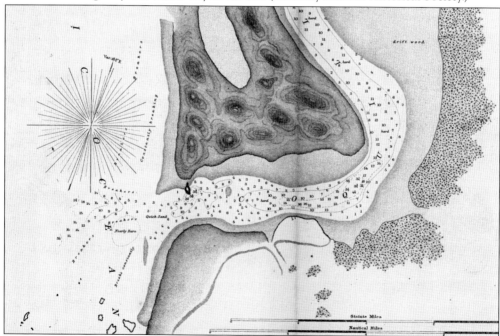

A CHALLENGING BAR. Maj. Nathaniel Michler doubted that the "shallow, shifty" sands at the mouth of the Coquille (depicted on this 1861 survey map) could ever be made navigable. While some criticized his pessimism and incredulity, it was true that the sands shifted so rapidly that information gained on one day's trip could not be relied upon for the next. (Courtesy National Oceanic and Atmospheric Administration.)

THE ISTHMUS DIVIDE SHOWED PROMISE. The Isthmus Divide was already a favored portage route for passengers and freight. In 1870, Gilbert Hall, sensing opportunity, improved it with a wooden tramway (pictured). Maj. Nathaniel Michler was impressed by how this slow, primitive system could move an astonishing 600 tons of freight per year. If the route was upgraded to a canal, Michler stated in a letter to Oregon senator John H. Mitchell, the route would "open a fine country" for more emigrants. (Courtesy Reg Pullen.)

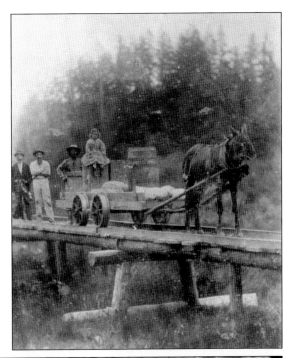

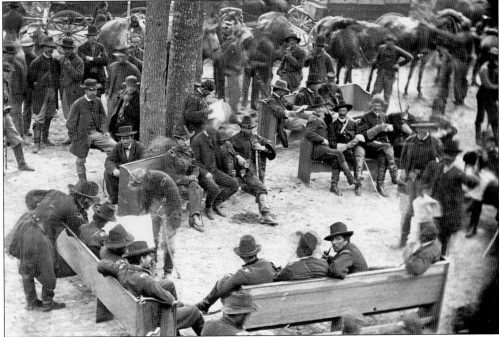

MICHLER AND THE PRESIDENT. In 1864, Lt. Gen. Ulysses S. Grant, shown here reviewing a probable Michler map that same year, picked Michler to plan reconnaissances and siege works for the closing battles of the Civil War. Michler served under Maj. Gen. Andrew A. Humphreys and was decorated for "gallant and meritorious service." By 1874, Grant was president and Humphreys was chief of the US Army Corps of Engineers; Michler's views on what to do with the Coquille River were thus guaranteed a sympathetic reception. (Courtesy Library of Congress.)

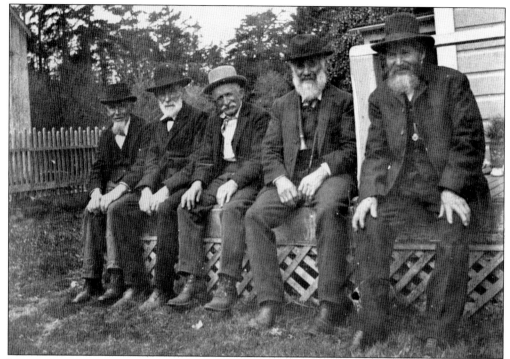

LOWER COQUILLE MILL OWNERS. Maj. Nathaniel Michler's proposal for a canal 20 miles up the Coquille River would not benefit the pioneers who had already committed their futures downstream. Sawmills owned by Grube, Pohl & Rink; Adam Pershbaker; and Fahy & Hamblock needed to ship downstream, out through the mouth of the Coquille. Pictured here in 1909 are, from left to right, "Young" John Hamblock, Edward Fahy, Chris Long, Adam Pershbaker, and "Old" John Hamblock (the two Hamblocks were brothers). (Courtesy Bandon Historical Society.)

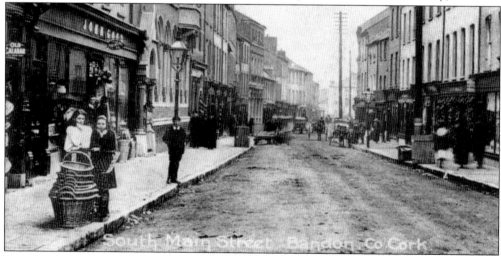

BANDON, IRELAND. Just before the canal proposal was announced, George Bennett (1827–1900) purchased land near the mouth of the Coquille. In 1873, Bennett had emigrated from Bandon, County Cork, Ireland, with his two sons. In 1889, Bennett platted the townsite of Bandon Beach, which merged with nearby Averill in 1891 to become Bandon. At various times in history, Bandon has sometimes been known as Bandon-by-the-Sea. (Courtesy Reg Pullen.)

DREAM OF A SEAPORT. Upon arriving in 1873, George Bennett thought the lower Coquille "the very place for a town. . . . the immense country behind, with its almost inexhaustible supply of valuable timber, and its hills and vales, where countless flocks of sheep and herds of cattle would be fed, when that country was cleared and settled, must have this as its shipping port." (Courtesy Bandon Historical Society.)

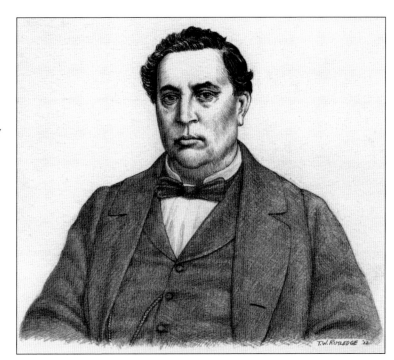

BENNETT REMEMBERS BEAVER SLOUGH. The 1874 canal proposal stood to ruin Bennett's dream of a seaport on the Coquille, so Bennett joined others in challenging the feasibility of the canal and championing improvements at the mouth. Bennett contributed to the effort, lightheartedly reminding everyone of the ooze, slime, muck, and filth attendant on a journey through Beaver Slough (pictured) in a poem published in the *Coos Bay News* in 1876. (Courtesy Reg Pullen.)

RALPH HEWITT ROSA. Civil War veteran Ralph Rosa (1848–1921) opened a store near the mouth of the Coquille in 1874 and served Coos County in the 1876 Oregon House of Representatives. He later served as a founding port commissioner. His efforts to secure federal funding to improve the Coquille are remembered as "indefatigable." Col. Rosa was described in the *Centennial History of Oregon, 1811–1912*, as "a true public servant, forceful, shrewd and able, with a discriminating judgment and unselfish consideration for the wishes of his constituents." (Courtesy Bandon Historical Society.)

JUDAH PARKER. Capt. Judah Parker (1829–1899) was a successful sailor, captain, and Spanish galleon treasure hunter. In 1875, he partnered with Meldon L. Hanscom to build a sawmill on the lower Coquille; in 1876, he introduced the *Katie Cook*, the first tugboat on the Coquille. Thus committed, Parker became a key advocate for improving the Coquille bar. (Courtesy Bandon Historical Society.)

A Coos County Party. By 1878, Judah Parker was tired of waiting for government intervention and started building his own rudimentary jetty. To raise money, he and other lower Coquille promoters hosted a memorable Fourth of July party. This illustration from the October 1856 edition of *Harper's New Monthly Magazine* shows one of the first Christmas parties in Coos County. (Courtesy Reg Pullen.)

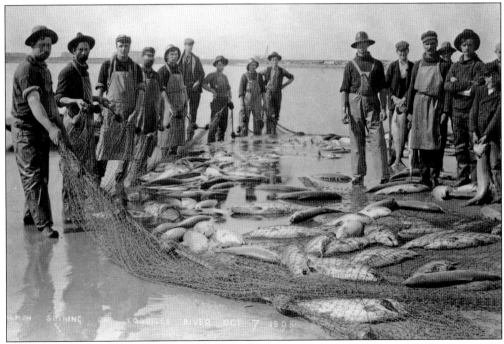

A Growing Market for Salmon. The Coquille was noted for an abundance of salmon. In 1878, the first barrel of salmon was shipped across the mouth of the river. George Bennett wryly noted that there were so many salmon, "they were a nuisance. We were all tired of them, fresh, salted, smoked, boiled, fried, in fact, every way." The area's first cannery opened in 1885. In this 1898 photograph, fishermen pose with their catch. (Courtesy Bandon Historical Society.)

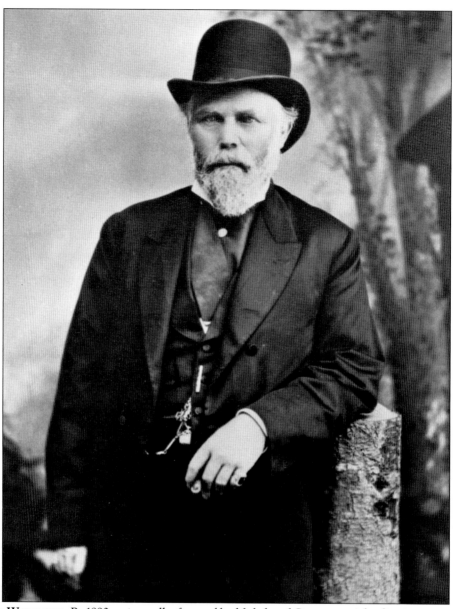

JOHN WHITEAKER. By 1880, serious talk of a canal had faded, and Congress was funding improvements at the mouth of the Coquille. Bandon's future as a major seaport was assured. Contemporaries credited John Whiteaker for this success before Congress. Whiteaker (1820–1902) had been Oregon's first governor (from 1858 to 1962) and, as Oregon's state senate president (from 1876 to 1879), had signed a joint memorial to Congress arguing that improving the Coquille would double the Coos County population and generate income for the nation in excess of the cost. Whiteaker was elected to Congress in 1879 and helped ensure the first appropriation. But credit must also go to the Coos and Curry County pioneers who, in the best American tradition, organized a local committee to advocate for their beliefs. As George Bennett, secretary of this committee, said, "All promised to act as one man, and to influence every one they could not to vote for anyone that didn't do everything in his power to promote the one great object we had in view and that was the wider opening of the mouth of our river." (Courtesy Oregon State Archives.)

Three
JETTIES, LIFE-SAVING, AND THE LIGHTHOUSE

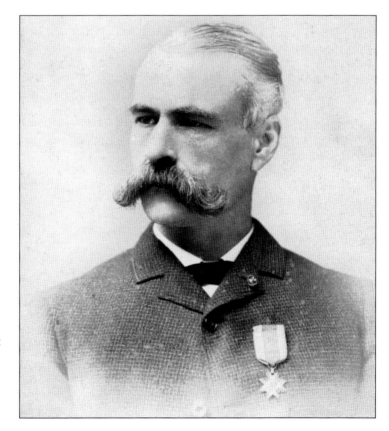

ROGER SHERMAN LITTLEFIELD. Bandon is the product of significant federal investment. The government-funded jetties, life-saving service, and lighthouse protected and encouraged the commerce upon which Bandon grew. Capt. R.S. Littlefield (1834–1896), a Civil War veteran, was the capable superintendent in charge during the critical early years of jetty construction. (Courtesy Bandon Historical Society.)

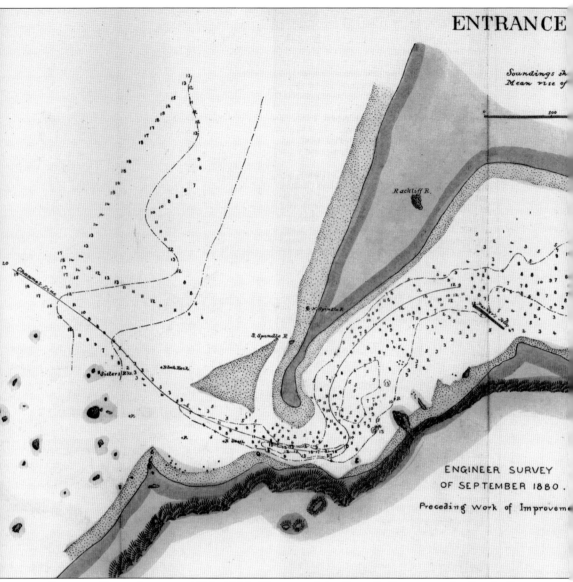

COQUILLE RIVER SURVEYS, 1880–1886. The exit of the Coquille River into the Pacific Ocean shifted over time. In 1860, the channel shot straight west; by 1880, as seen above, the channel had wound its way to the south. The unpredictable movement of the channel made navigation difficult. A partial solution involved constructing rock jetties on both riverbanks—jetties concentrate and

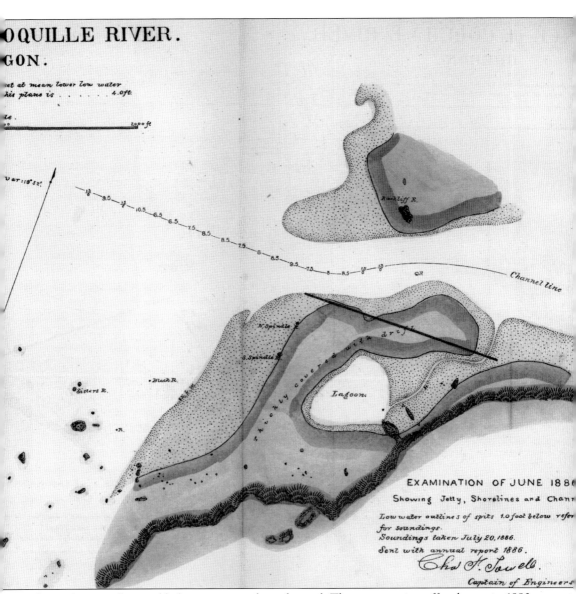

direct the river flow and help scour out a deep channel. The construction effort began in 1880 and was substantially complete by 1908, but maintenance and repairs to the jetties continue to this day. (Courtesy Bandon Historical Society.)

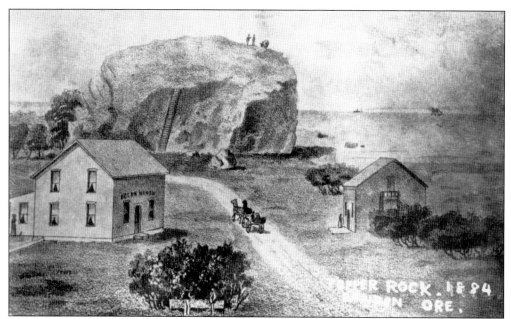

TUPPER ROCK. A local source of material for the jetties was Tupper Rock, a monolith of blueschist located on the south side of the Coquille River near the mouth. The rock was named after John Tupper, who owned the property on which it stood. Although it is now quarried out, Tupper Rock towered above and in front of the bluff facing the ocean, and it can be difficult to imagine how it must have dominated the local scenery. The Coquille Indian Tribe remembers and values Tupper Rock as "Grandmother Rock," a sacred site for Nasomah gathering and storytelling. The image above shows Tupper Rock in its original condition in 1884; the image below shows Tupper Rock being quarried out during the 1890s. (Both courtesy Bandon Historical Society.)

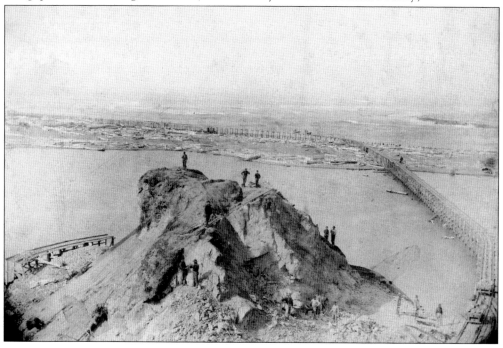

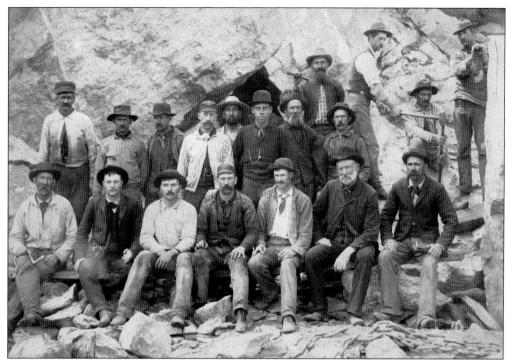

CONSTRUCTING THE JETTIES. The basic construction technique involved quarrying the stone, derricking it onto transports, and then dumping it in advance from a raised tramway. The stone had to be barged across the river for the jetty on the north side. In the December 16, 1915, edition of the *Western World*, an editorial praised the construction efforts for giving local men an opportunity to work: "in fact it could easily be said that the government works, for the size of the crew, employed more local men than would have worked under a private contractor." (Both courtesy Bandon Historical Society.)

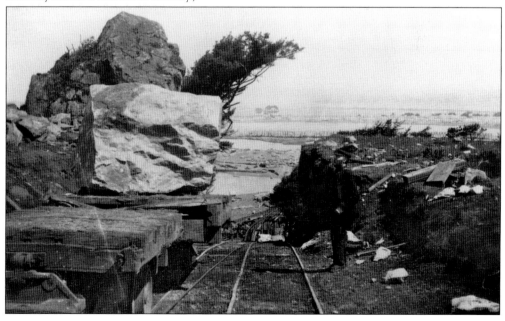

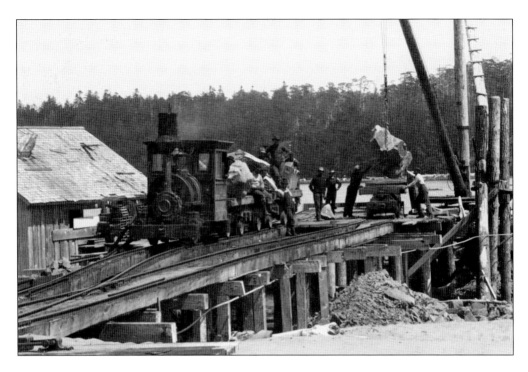

IMPROVING CONSTRUCTION KNOWLEDGE. Appropriations were piecemeal, and government engineers expressed frustration that the necessary work could not be accomplished all at once. Each spring, repairs necessitated by the previous year's winter storms diminished funds available for new work. The Oregon coast is a challenging classroom, but the Portland district of the US Army Corps of Engineers studied its experiences and continually improved its designs and techniques to meet the needs of a growing region. (Above, courtesy Bandon Historical Society; below, courtesy National Archives at Seattle.)

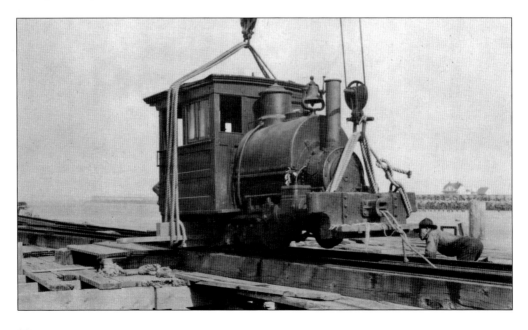

BLASTING UNDERWATER ROCKS. Underwater rocks were sometimes dynamited to improve channel depth and safety. The state also received periodic appropriations for clearing and removing snags and other hazards to upriver navigation. In 1859, it was an achievement for Capt. William Rackleff to sail his *Twin Sisters* small schooner all the way up the Coquille River to Myrtle Point. By 1915, vessels up to four times the size of *Twin Sisters* could make it to Coquille City, and a steamer carrying upward of one million board feet of lumber could safely navigate the river's mouth at Bandon. (Above, courtesy National Archives at Seattle; below, courtesy Bandon Historical Society.)

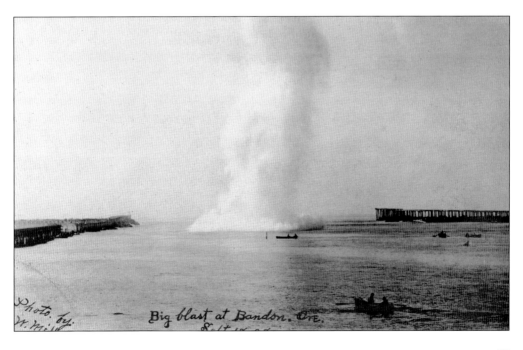

BINGER HERMANN. Hermann (1843–1926), who was a leader for Oregon waterways improvements while serving in the US House of Representatives from 1885 to 1897 and 1903 to 1907, may be largely credited for bringing the US Life-Saving Service and a lighthouse to Bandon. He arrived in the Coquille Valley in 1859 and was a founder of Myrtle Point, Oregon, in 1875 and 1876. (Courtesy Reg Pullen.)

BANDON LIFE-SAVING STATION. Congress approved a US Life-Saving Service station for Bandon in 1889, and the station was completed in 1891. The station was built on the Marquette plan, with a Fort Point–type boathouse. Located on First Street on the west end of the Bandon waterfront, the station had a launchway that descended directly into the water. (Courtesy Bandon Historical Society.)

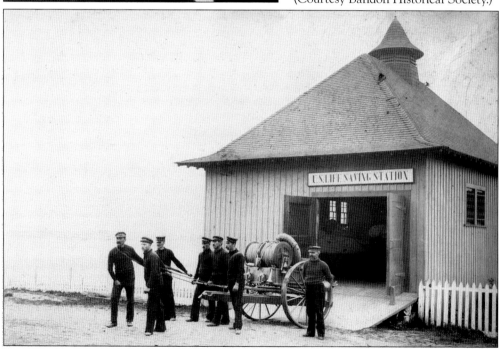

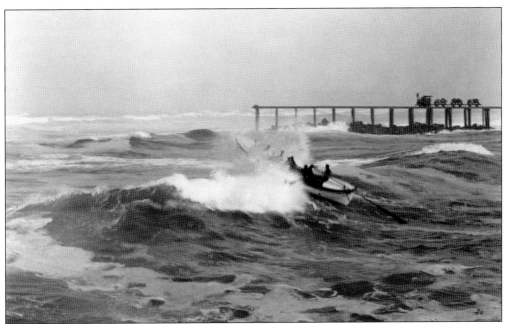

MEN OF VALOR. The unofficial motto of the US Life-Saving Service was: "We have to go out; we don't have to come back." The US Life-Saving Service annual reports for the years 1868 to 1914 list 64 strandings on the Coquille River bar, more than anywhere else along the Pacific coast. The Life-Saving Service members, as seen in the c. 1891 image below, were unassuming men, some middle-aged, some living away from home and family. They pulled their weight and relied on their judgment of the sea and their crewmates. They gave their best, sometimes forfeiting their lives in the course of duty. (Both courtesy Bandon Historical Society.)

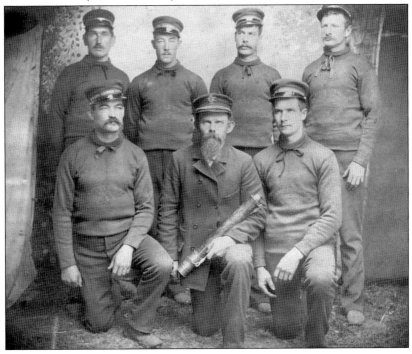

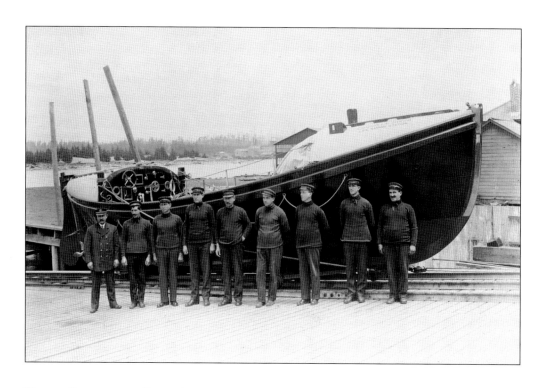

HONOR, RESPECT, AND DUTY. In January 1915, an act of Congress combined the US Life-Saving Service and the Revenue Cutter Service to form the US Coast Guard. The Coast Guard watches over the Bandon bar to this day, and its core values of honor, respect, and devotion to duty are firmly rooted in a distinguished history of contributions to the developing Bandon economy. In the above photograph, Capt. Robert Johnson (far left) and his men pose with a 36-foot motor lifeboat in 1912. Below, Coast Guard servicemen practice during a capsize drill. (Above, courtesy Bandon Historical Society; below, courtesy Brian Vick.)

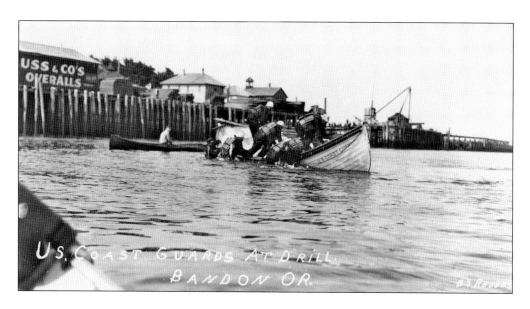

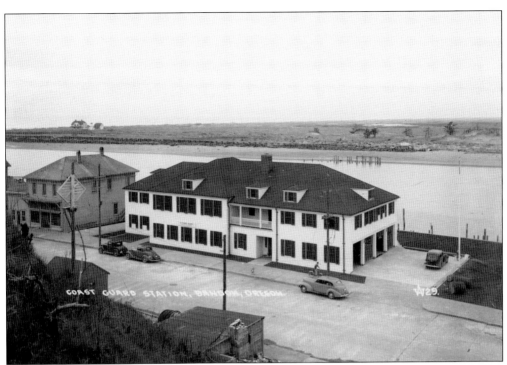

COAST GUARD IN THE 1940S. The Bandon fire of 1936 destroyed the old Coast Guard station. The new Coquille River Life Boat Station (above), built in 1939 on the same site in order to take advantage of the existing launchway, was used in World War II as headquarters for naval coastal lookouts and beach patrols (below). The Coast Guard decommissioned the station in 1946, and it was listed in the National Register of Historic Places in 1984. It is now the headquarters for the Port of Bandon, and auxiliary office space is rented out to businesses. (Above, courtesy Oregon Historical Society; below, courtesy Coast Guard Museum Northwest.)

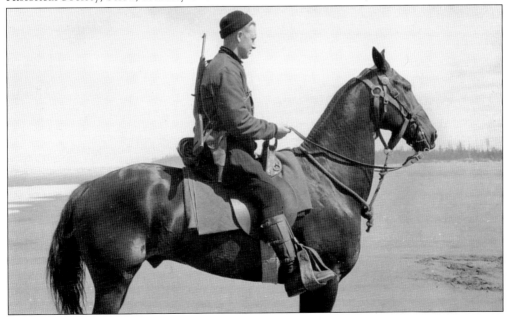

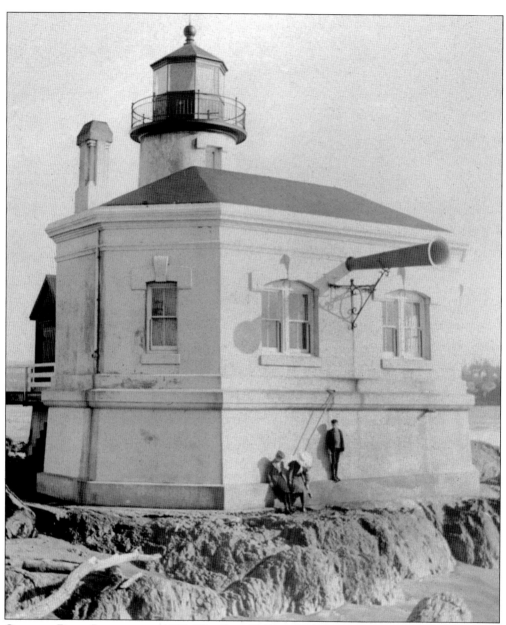

COQUILLE RIVER LIGHTHOUSE, 1921. The Coquille River Lighthouse was built in 1896 and served Pacific Ocean mariners until 1939, when technical navigational apparatuses and automated lights made beacons, foghorns, and lighthouses obsolete. It was equipped with a Fourth Order Fresnel lens, illuminated by a Funck-Heap lamp, and visible for 12 miles at sea on a clear night. The beam was illuminated for 28 seconds, then off for 2 seconds, signifying a harbor light. The foghorn was originally a DaBoll trumpet that blasted for 5 seconds, then was silent for 25 seconds; this was replaced with a fog siren in 1910. The keeper's house, which no longer exists, was a duplex situated 650 feet away. The lighthouse, which was listed in the National Register of Historic Places in 1974, remains a fitting symbol of the federal investment that underwrote the growing prosperity of Bandon. (Courtesy Bandon Historical Society.)

Four

THE GOLDEN AGE

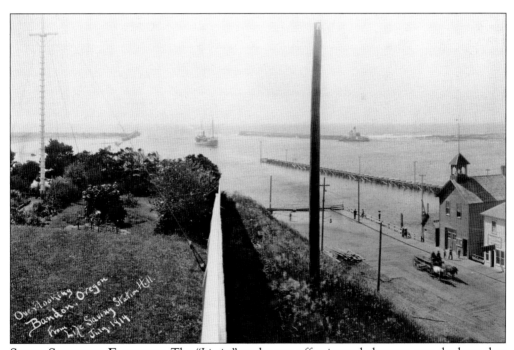

STEAM SCHOONER *ELIZABETH*. The "Lizzie," as she was affectionately known, was the boat that built Bandon. Between 1904 and the late 1920s, the *Elizabeth* made over 700 round trips between Bandon and San Francisco. "Lizzie" was almost always loaded to capacity with passengers, lumber, cheese, and milk. "Everything from grand opera to the day of judgment was supposed to come on the boat," reported the *Western World* in March 1925. (Courtesy Bandon Historical Society.)

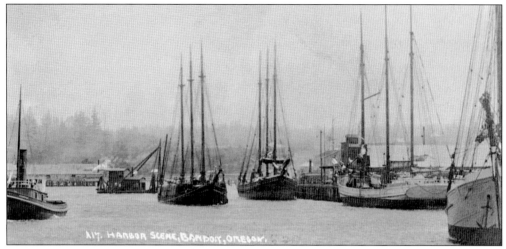

A GROWING SHIPPING PORT. Bandon was growing, and the 1906 San Francisco earthquake accelerated demand for building materials. In 1913, nearly 200,000 tons crossed the mouth of the river. By 1916, Bandon was exporting 87 million board feet of lumber, five and a half million feet of ties, 3,500 pieces of piling, 5,000 poles, five and a half million shingles, 600 cords of matchwood, 13,000 bundles of splints, 250,000 box shooks, 1,000 tons of coal, and thousands of cases of salmon and dairy products each year. (Courtesy Brian Vick.)

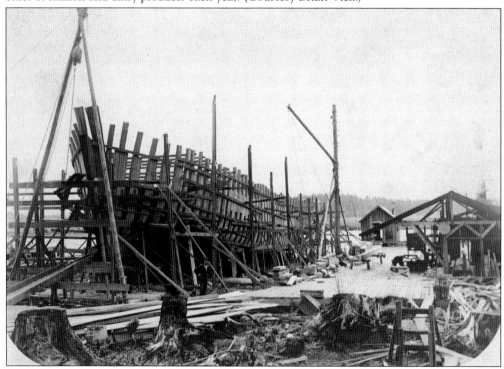

SHIPBUILDING. Shipbuilders were located all along the Coquille River. In Myrtle Point, the main shipbuilder was Rackleff; in Coquille, Ellingson and Rackleff; in Parkersburg, Grube, Pohl & Rink; at Randolph and Prosper, Herman Bros. and Heukendorff; at Bullards, Price; and at present-day Bandon, Price and Reed. This 1905 picture of the Heukendorff shipyard shows construction of the *Oregon*, the largest ship built on the coast that year. (Courtesy Bandon Historical Society.)

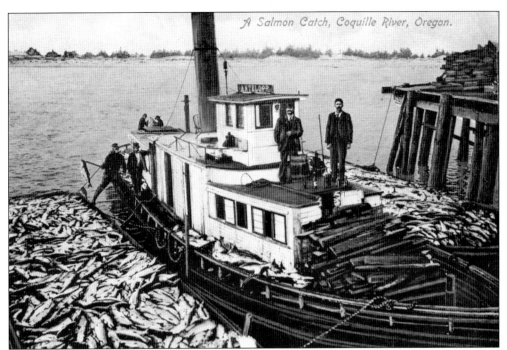

SALMON AND THE TIMMONS CANNERY. Gill net fishing camps lined the banks of the lower Coquille River at the turn of the 20th century. Boats like the *Antelope* (above), which was owned by the Panter family, would travel upstream each morning to pick up salmon caught the night before. Salmon were processed at the Timmons cannery in Bandon and farther upriver in Prosper and Parkersburg. Chinese workers from San Francisco were brought in to fillet and pack the fish. The Coquille was a remarkably productive fishery, producing upward of 100,000 salmon annually through 1925. (Above, courtesy Bandon Historical Society; below, courtesy Brian Vick.)

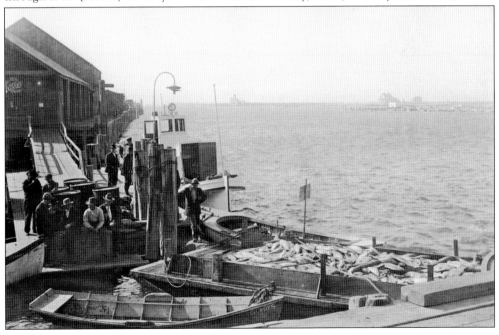

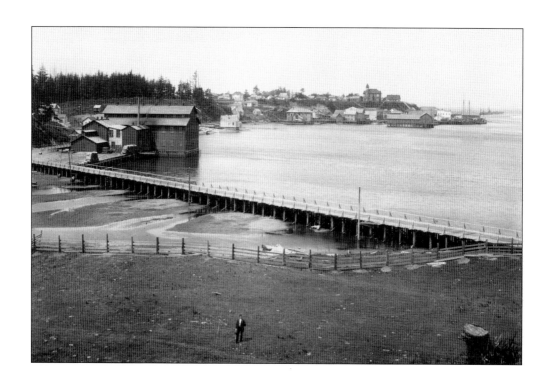

TOWN VIEWS. While reviewing historic photographs of Bandon, it is important to remember that much of the present-day "Old Town" and waterfront was built on pilings and fill over a shallow bay and mudflats. The wooden walkway in the above photograph connected Bandon with Prosper, which was a few miles upstream. The large building at left is the Woolen Mill that was built in 1893. The most prominent building on the waterfront is the Timmons Cannery. The structure on the bluff with the bell tower is the first public school, which was located next to the Life-Saving Service/Coast Guard house. (Both courtesy Bandon Historical Society.)

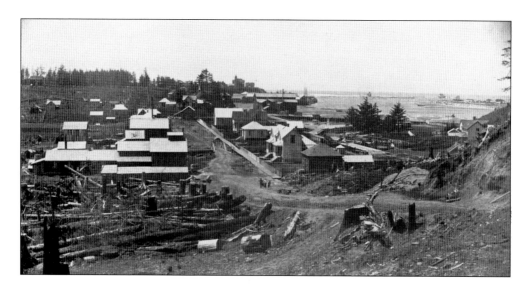

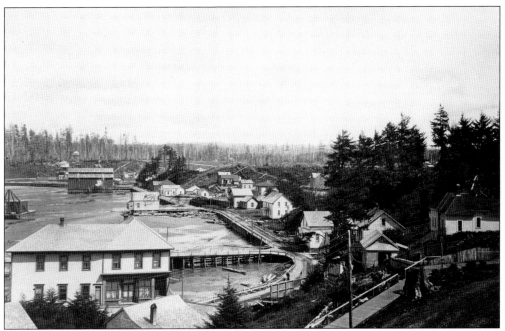

LOOKING EAST ON SECOND STREET. Ralph Rosa's store is the waterfront building in the center, and the Woolen Mill is the large building behind it. In the ensuing years, the bay in front of Second Street would be filled in and become the center of Bandon's business district. (Courtesy Bandon Historical Society.)

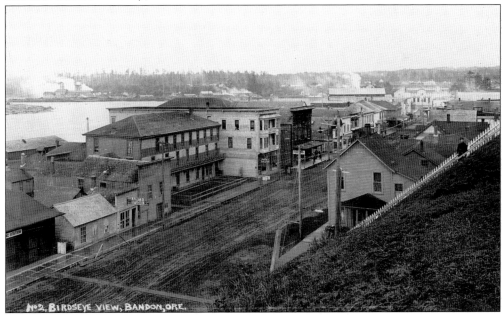

LOOKING EAST ON COAST GUARD HILL. The Gallier Hotel, with its multiple guest room windows, is at the center of Bandon's business district. Established in 1900 by Stephen and Ed Gallier, the 106-room hotel was one of the finest establishments in the region. In 1907, steam-powered electricity started flowing in Bandon. The buildings here are crammed together, stretching in a thin line between the Coquille River and plank-lined First Street. (Courtesy Bandon Historical Society.)

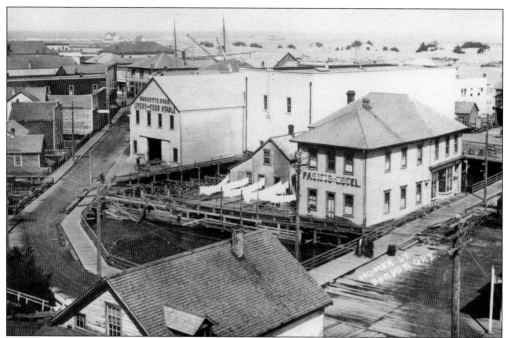

LOOKING NORTHWEST OVER BANDON. The Pacific Hotel (right of center in the photograph) was Bandon's earliest hotel and was built by the Garoutte Brothers. The rapidly growing town was constructed on pilings over the river, and garbage disposal simply meant dumping refuse into the river as the tide was going out. Masts of seagoing vessels are visible in the background, and the lighthouse keeper's residence is visible in the distance at top left. (Courtesy Bandon Historical Society.)

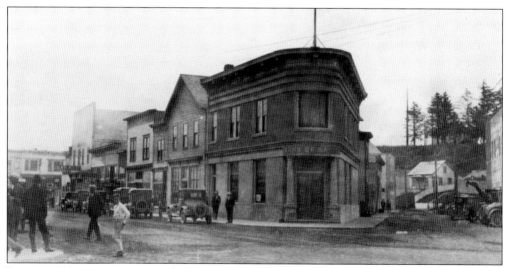

BANK OF BANDON, C. 1920. The Bank of Bandon, established in 1904, reflected the town's growing prosperity. J.L. Kronenberg was the bank's first president. In 1910, the bank reopened at a new location—the "flatiron building" pictured here—on Second Street. (Courtesy Bandon Historical Society.)

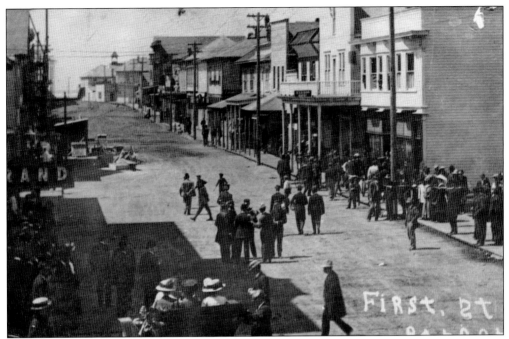

LOOKING WEST ON FIRST STREET. Bandon bustles with activity in this c. 1920 photograph. The economy was driven by sawmills, wool mills, canneries, creameries, and an assortment of other businesses. Restaurants, hotels, drugstores, and clothing retailers were tightly compressed to take advantage of every foot of land near the waterfront. (Courtesy Bandon Historical Society.)

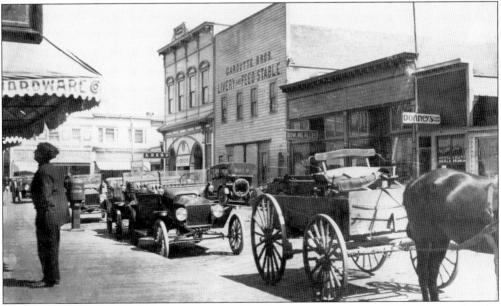

CENTER OF BANDON. Cars and wagons share Bandon's streets in this c. 1920 photograph. The Garoutte Brothers Livery and Feed Stable originally took care of horses, but it was soon converted into a garage for automobiles. The Grand Theatre is next to Garoutte Brothers, and the Ellingson Building, which housed the town's largest drugstore, is in the left foreground. (Courtesy Bandon Historical Society.)

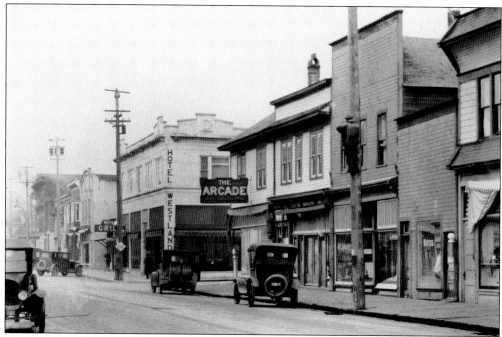

FIRST STREET LOOKING WEST, C. 1925. The first store at right is McNair Hardware Company, founded in 1898 and one of Bandon's longest-running businesses. The Arcade was a popular saloon for loggers and fishermen who flooded the town on weekends. The Hotel Westland is just past The Arcade. (Courtesy Bandon Historical Society.)

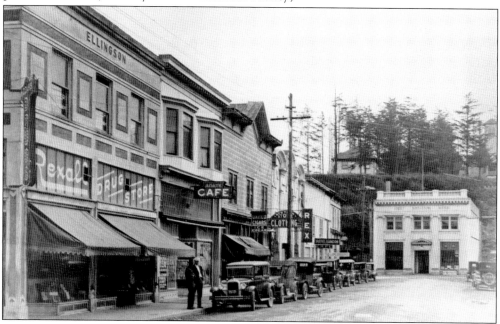

ALABAMA STREET, C. 1928. Ford Model T automobiles line the street in the heart of the business district. The First National Bank Building, constructed in 1913, stands at the end of the street. Half of the bank building was occupied by Bandon's longest-running newspaper, the *Western World*. (Courtesy Bandon Historical Society.)

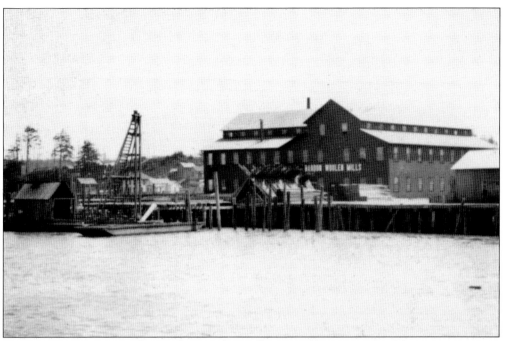

BANDON WOOLEN MILL. The Bandon Woolen Mill, pictured here around 1906, was an important early business. It manufactured carriage linings for the Eastern market, as well as flannels, cashmeres, and men's suitings. By 1910, the mill was producing gray, white, and scarlet blankets. Numerous ranches from Bandon to Langlois, in the south, provided the wool. (Courtesy Bandon Historical Society.)

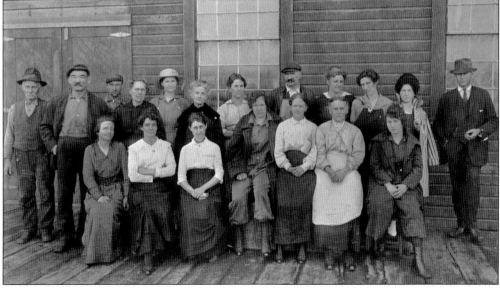

BANDON WOOLEN MILL CREW, 1898. In 1898, the Bandon Woolen Mill employed 29 people, 12 of whom were women. By 1907, the mill had a payroll of $2,000 and was shipping $7,000 worth of goods per month. Around 1914, the mill's owners changed its name to Sunset Woolen Mills, and in the 1920s, the operation was converted into a battery separator plant. (Courtesy Bandon Historical Society.)

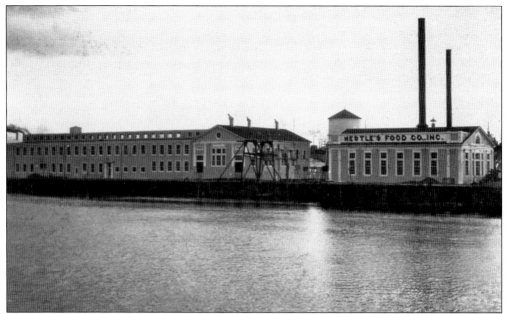

NESTLÉ MILK CONDENSERY, C. 1920. Dozens of dairies utilized the lush bottomlands of the Coquille Valley, including some that supplied Nestlé, which took advantage of the opportunity to buy into Bandon in 1919. In 1922, the waterfront Nestlé plant produced six and a half million pounds of canned, condensed milk annually and handled 150,000 pounds of milk per day. The plant closed in 1926 due to water problems from the Ferry Creek Reservoir and competition from smaller, more efficient cheese plants. (Courtesy Bandon Historical Society.)

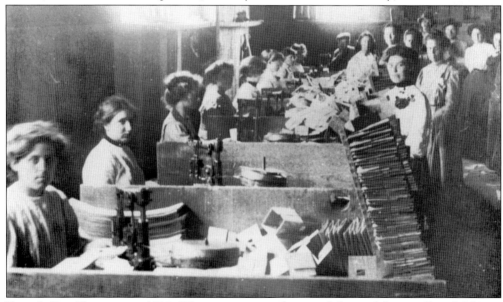

PERRY'S BOX FACTORY, C. 1930. Women constituted most of the workforce at Perry's Veneer and Box Factory, established by F.S. Perry in 1910. The company specialized in making boxes and battery separators from Port Orford cedar. The box factory was one of the few buildings that survived the fire of 1936, after which it was used as a temporary city hall. (Courtesy Bandon Historical Society.)

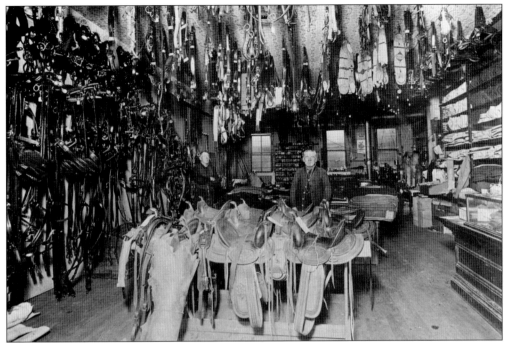

SADDLE SHOP, C. 1900. Bandon was positioned to take advantage of the rich resources of the Coquille River valley. Much of the land to the south and east was open prairie capable of supporting large herds of cattle and flocks of sheep. Saddles, reins, and bridles were in great demand. (Courtesy Bandon Historical Society.)

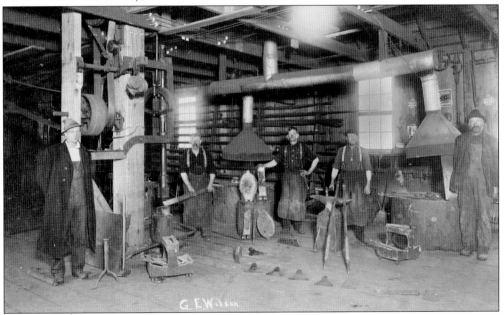

G.E. WILSON BLACKSMITH AND MACHINE SHOP, C. 1920. One of the most important businesses in early Bandon was the blacksmith and machine shop. Employees at local farms, sawmills, canneries, and logging camps used tools forged at the shop. The post-and-beam construction of this building was common for most early commercial structures. (Courtesy Bandon Historical Society.)

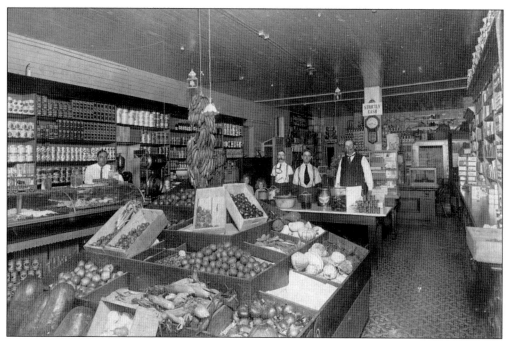

GROCERY STORE, C. 1930. Several grocery stores supplied early residents with a variety of produce. Exotic items like bananas and oranges arrived weekly via supply ships from California. Using credit was apparently not an option at this store. (Courtesy Bandon Historical Society.)

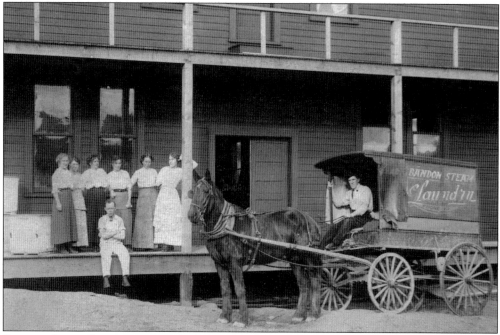

BANDON STEAM LAUNDRY, C. 1910. Before the advent of washing machines, the steam laundry was important in early Bandon. As with most of the businesses in town, the laundry's energy was provided by wood-fired boilers. This laundry burned down in 1913, presaging the 1914 fire that destroyed much of the Bandon business district. (Courtesy Bandon Historical Society.)

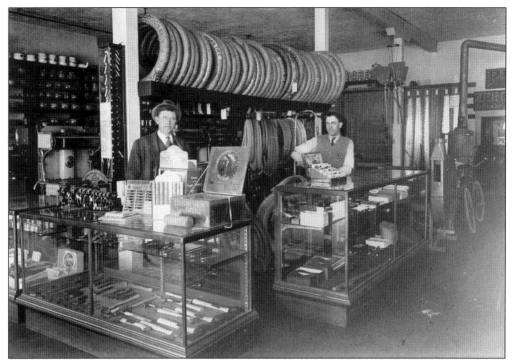

DOWNTOWN VARIETY STORE. Then, as now, merchants strove to be responsive to demand, filling their stores with wares calculated to sell. This store sold saws, tires, razors, fishing equipment, tools, and sharpening equipment. (Courtesy Bandon Historical Society.)

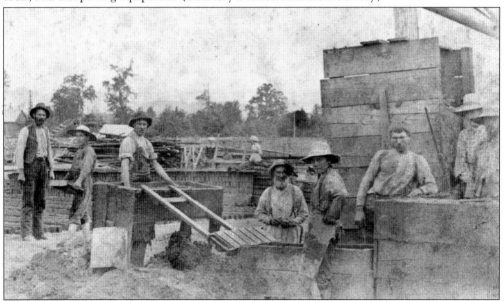

BANDON BRICKYARD, C. 1884. This rare photograph shows Bandon's brickyard, which was southeast of town in the present-day location of the Southern Coos Hospital and Health Center. Local brick was poor quality and was mainly used for chimneys and fireplaces. The absence of good clay would become a serious hindrance for the growing community. (Courtesy Bandon Historical Society.)

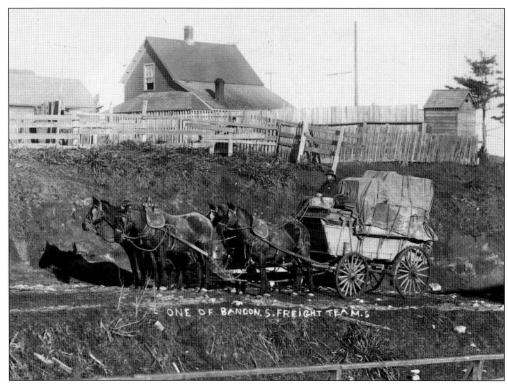

FREIGHT TEAM, C. 1880. The river was the highway, so until roads were improved, freight teams were used to transport supplies from the docks of Bandon to remote ranches to the south and east. John Safley, pictured here in his wagon, made his living negotiating the muddy tracks that led to places like Langlois and Myrtle Point. The easiest journeys were made on the beach at low tide. (Courtesy Bandon Historical Society.)

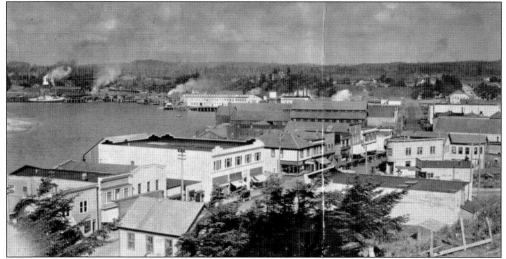

BANDON IN THE 1930S. As the Great Depression began, Bandon still enjoyed a fair measure of prosperity. The smokestacks of Moore Mill Lumber Company, the economic engine that drove the community for over 80 years, are in the background. Bandon had spread over a much larger area than during its rudimentary beginnings in the 1870s. (Courtesy Bandon Historical Society.)

Five
A Spirit Unbroken

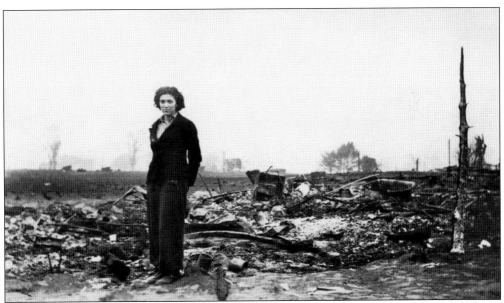

TESTED BY TRAGEDY. The fire that descended on Bandon on the Saturday evening of September 26, 1936, was not the first fire to challenge the community. But as the most devastating fire in Bandon, the event remains one of the most significant in the city's history—an event that reshaped the architecture of the town and revealed the resilient, generous nature of its residents. Here, Annabelle Jacobs stands amid the destruction caused by the fire. (Courtesy Bandon Historical Society.)

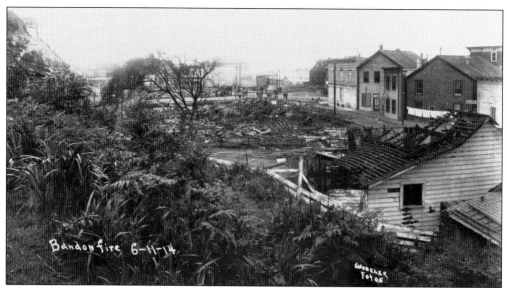

THE 1914 FIRE. Bandon experienced at least one major fire before the 1936 event. In 1914, a blaze that originated in a restaurant burned down most of the downtown district, destroying 20 buildings. Fortunately, no lives were lost, and residents rebuilt the district within a year. (Courtesy Bandon Historical Society.)

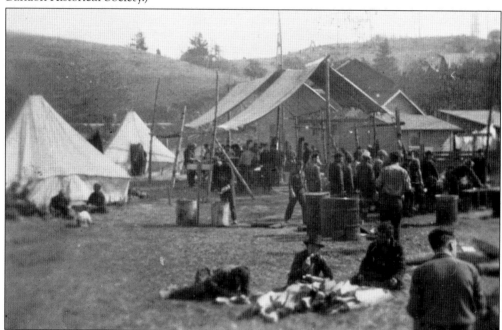

RURAL FIREFIGHTER CAMP. Area fire officials were worried on the morning of Saturday, September 26, 1936. Small fires burned throughout western Oregon, and fire conditions were the most extreme of any recorded year with low humidity and a persistent east wind. By evening, fires threatened buildings, timber, and farmland from Seven Devils Road to the north, Elk River to the south, and Lampa Mountain to the east. The US Forest Service, the Civilian Conservation Corps, the Coos Forest Patrol, and loggers, farmers, and residents throughout the county did what they could to save lives and property. (Courtesy Bandon Historical Society.)

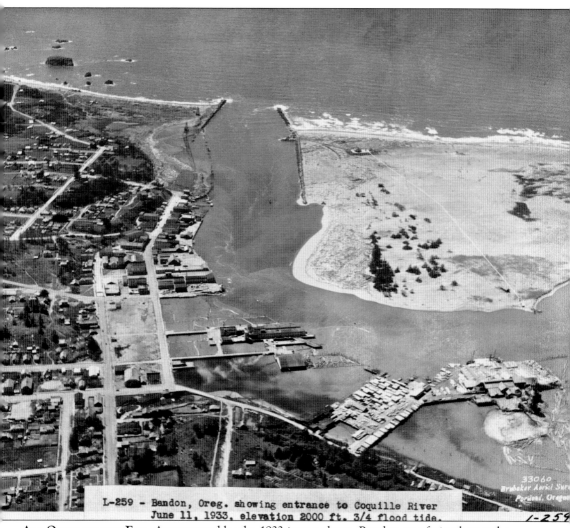

L-259 - Bandon, Oreg. showing entrance to Coquille River June 11, 1933, elevation 2000 ft. 3/4 flood tide.

ALL QUIET ON THE EVE. As suggested by the 1933 image above, Bandon was faring better than many cities during the Depression. The Moore Mill Lumber Company was the area's largest employer, and International Cedar, Nestlé, Perry, and Acme offered meaningful industrial jobs. The city's waterfront was a bustling business district served by schooners journeying from cities along the Pacific coast from San Francisco to Portland. Dow Beckham, author of *Bandon By-The-Sea: Hope and Perseverance in a Southwestern Oregon Town*, writes that on the eve of the fire, Charley Page's Arcade was noisy with the clatter of pool balls and the banter of men out on the town. People were getting ready for the dances at Dew Valley and the Silver Spray Gardens, and the Hartman Theatre was showing a film called *36 Hours to Kill*. "No one seemed to be worried about a forest fire interfering with their Saturday night fun. The scene and mood changed suddenly as smudge-faced fire fighters straggled into town stating that the red demon was completely out of control and was only three miles away." (Courtesy Oregon Historical Society.)

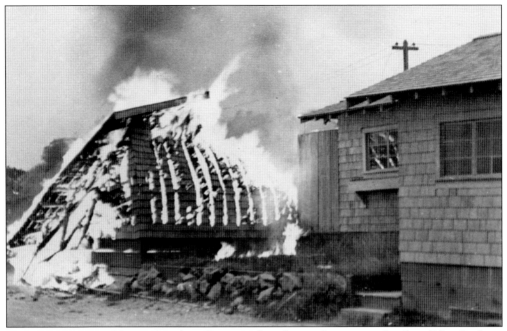

PREPARING FOR THE WORST. Rural residents north and east of town were hit first. Edna Paulsen, who was 12 years old in 1936, remembers telltale smoke in the air on Friday at her family's farm on present-day Morrison Road. When they spotted the flames cresting the hill from the east on Saturday morning, the men lit backfires in the woods. (Courtesy Bill Huggins and the Bandon Historical Society.)

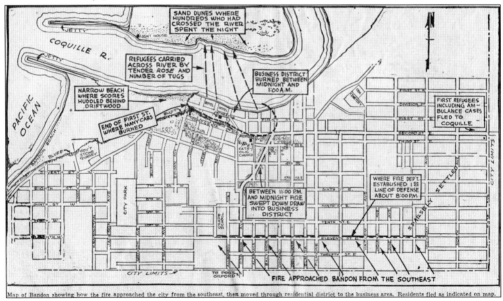

FIRE AT THE GATES. The first of Bandon's homes caught fire at approximately 9:00 p.m. on Saturday. Once inside city limits, the fire, carried by the wind, seemed to leapfrog through the residential districts. Survivors later noted that the heat was so intense that buildings seemed to explode before a spark touched them. The flames from large buildings such as the Gallier Hotel reached hundreds of feet into the air. (Courtesy *Sunday Oregonian*.)

CALL TO ACTION. Fire chief Curly Woomer had been battling fires all day, and by late evening, his men were tired and surrounded by fire. He raced to the Hartman Theatre to interrupt the film and ask for help. Word spread, and Chief Woomer soon had 400 volunteers under his command. (Courtesy Bandon Historical Society.)

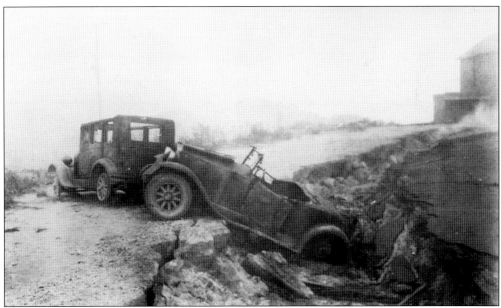

ESCAPING FROM TOWN. Bud Baird, then a junior in high school, was among the volunteer firefighters recruited from the movie theater. As the fire zigzagged through town, residents attempted to secure their loved ones, pets, and a few belongings. Those hoping for a speedy retreat westward toward the water found streets clogged with flame and smoke. Years later, Baird recalled the wailing sound of short-circuited car horns blaring from burning vehicles. (Courtesy Bandon Historical Society.)

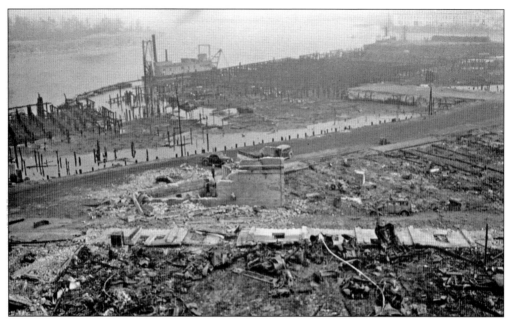

RESCUE BY WATER. For many fire survivors, rescue came by water. The US Coast Guard steamer *Alvarado*, the lighthouse tender *Rose*, the Port of Bandon tug *Klihyam*, and smaller private vessels ferried survivors to safety on the north bank of the Coquille River. In addition to emergency transport, public boat crews were able to provide shelter, food, and continued radio communication after the fire destroyed Bandon phone lines. The *Klihyam* crew used the boat's tug pumps to slow fires on the waterfront. (Courtesy Bandon Historical Society.)

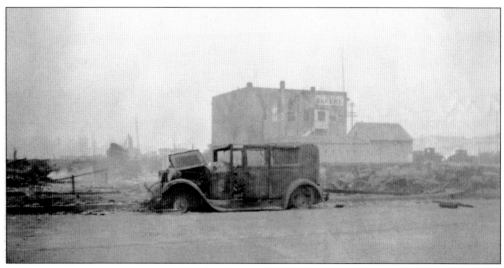

END OF AN ERA. By 2:00 a.m. on Sunday, September 27, the city of Bandon had burned to the ground. Its business district was a charred ruin. A total of 23 people died during the fire or as a result of injuries from it. (Courtesy Bandon Historical Society.)

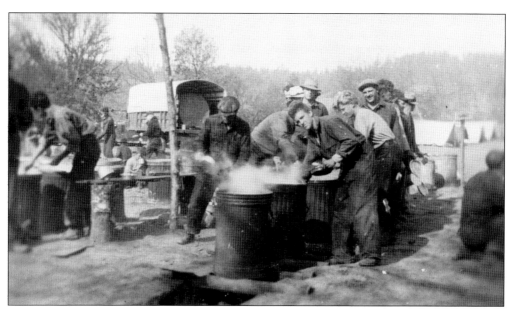

COUNTYWIDE DESTRUCTION. The rubble that was Bandon continued to smolder as Saturday night melted into dawn. Fire crews found no rest on Sunday, as blazes continued to consume timber and farmland throughout Coos and Curry Counties. (Courtesy Bandon Historical Society.)

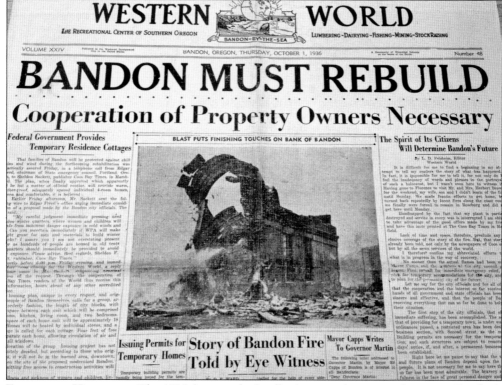

FIRE IN THE HEADLINES. The 1936 fire—undoubtedly the most documented event in Bandon's history—made news across the state and country. Reporters penned startling headlines to accompany front-page photographs of the fire and its aftermath. (Courtesy Bandon Historical Society.)

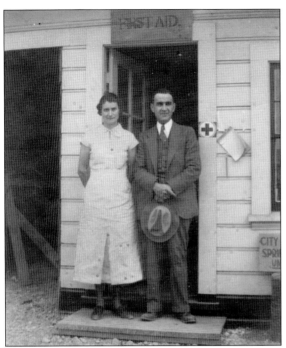

MEDICAL PERSONNEL ARRIVE. Assistance for the Bandon community arrived quickly; medical personnel from Myrtle Point got to town on Sunday morning. Norma Howe, RN, and Dr. Ellsworth Lucas (both pictured at left) helped staff a medical station at the Bob-Otto Court motel. (Courtesy Bandon Historical Society.)

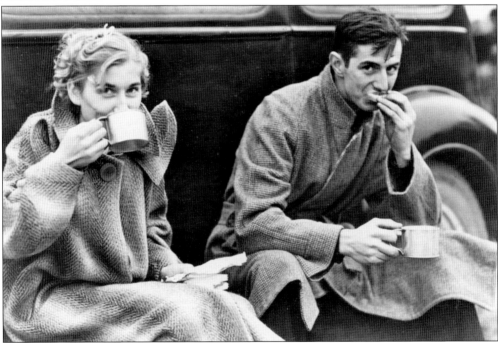

GRATITUDE FOR RELIEF. In a *Western World* article, Bandon mayor Ed Capps showed appreciation for the assistance his city received: "The enormity of the catastrophe that has befallen our city and its people has left us so incapable of coordinating our faculties that we shall not even attempt to give adequate expression to our neighbors and friends throughout the county, state, and nation, for their sympathy and their whole-hearted response in material assistance for the relief of those who have suddenly been left destitute." (Courtesy Bandon Historical Society.)

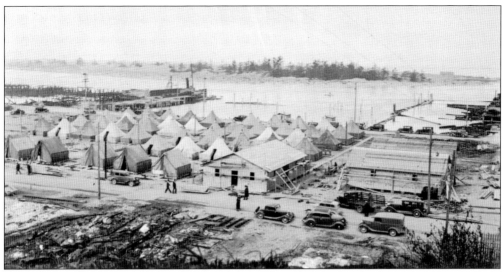

RED CROSS TENT CITY. Bandon residents did their share of work after the fire. One human interest story involves Lillian Farley, a primary school teacher and volunteer for the Red Cross who was distributing clothing when a reporter snapped her photograph. She suddenly felt self-conscious about her mismatched outfit and unkempt hair. Later, when a friend offered Farley a comb and bobby pins, she accepted the accessories as precious gifts. (Courtesy Bandon Historical Society.)

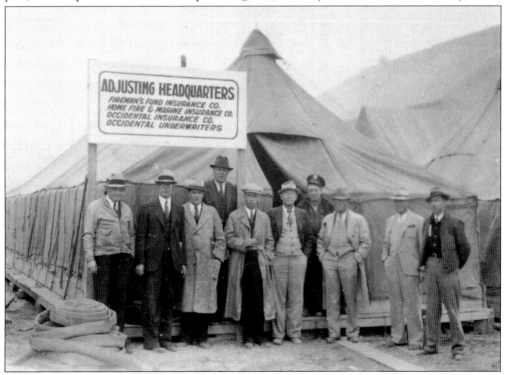

TIME TO REBUILD. Insurance company representatives worked from a relief tent. The largest portion of the damage was in property and public buildings, utilities, and schools. City officials set to the task of rebuilding, mindful that success would require both public and private cooperation. (Courtesy Bandon Historical Society.)

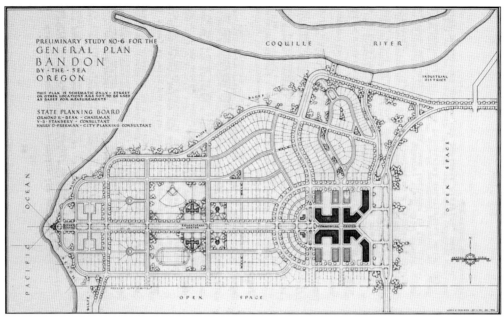

PLAN FOR A NEW BANDON. The destruction of Bandon meant an opportunity to rebuild from a clean slate. The city council, in coordination with community leaders and the state planning board, devised a plan for a new city organized around modern principles. Ultimately, there was not enough money available to resolve the financial and legal difficulties for a wholesale relocation of the city up the bluff and away from the waterfront. (Courtesy City of Bandon.)

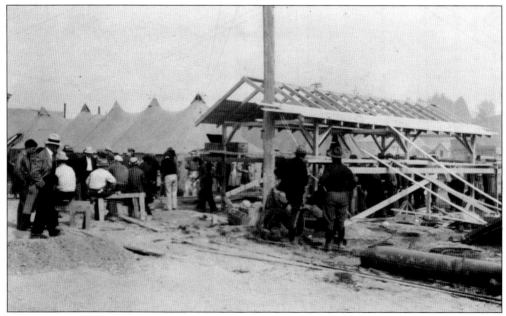

REBUILDING. Life and business moved forward while city leaders worked on the plan for a new Bandon. Many businesses created "temporary" establishments that became permanent. (Courtesy Bandon Historical Society.)

REMEMBERING LOCAL HEROES. It is impossible to name all of those whose bravery helped secure the safety of others on September 26, 1936. Among those later commended were Evelyn Manceit, who stayed at her post as Bandon telephone operator while the city burned, tenaciously relaying reports to officials outside of the city. She was persuaded to leave only when the bank building that housed the telephone office caught fire. (Courtesy Bandon Historical Society.)

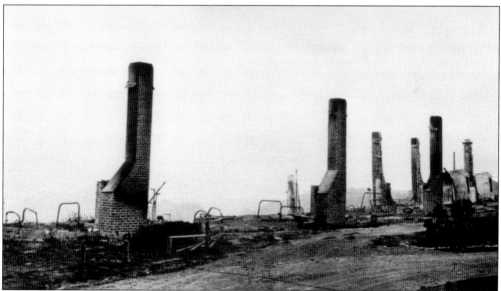

GORSE AND THE FIRE. Founding settler George Bennett had imported a shrub called Irish furze, or gorse, to help protect the ocean bluffs from erosion and serve as hedgerows. The plant spread, growing thickly between scattered houses. While gorse was not the cause of the 1936 fire, the oily shrub was easily ignited and certainly contributed to the destruction of Bandon. Rows of brick fireplaces were all that remained of most neighborhoods. (Courtesy Bandon Historical Society.)

75th Anniversary of Fire. On September 25, 2011, the Bandon Historical Society hosted a 75th anniversary commemoration of the 1936 fire. The gathering included many survivors who told additional stories that were recorded for posterity. Bandon mayor Mary Schamehorn read a proclamation declaring that Bandon's spirit was unbroken by the tragedy. The 2011 event recalled the closing lines of "The Destruction of Bandon," a poem written in 1937 by Retta Mullen. (Courtesy Geneva Miller.)

> The bravery of those noble few
> The firemen and coast guard crew,
> And loyal faithful volunteers,
> Toiled in smoke, thru blinding tears.
> Their bravery spread throughout the land,
> Deeds, thru future years will stand,
> But in their souls, on memory's page,
> Shall live that night, throughout the age.

Six
TIMBER, LOGGING, AND LUMBER

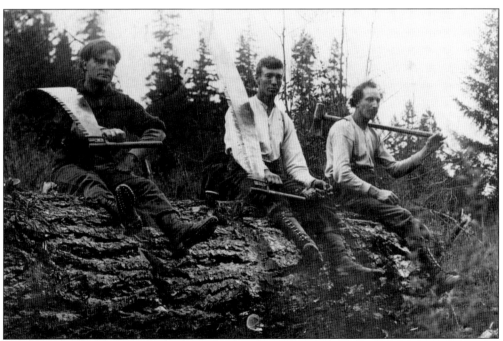

LOGGERS AT PROSPER MILL, 1915. Logging crews outfitted themselves with caulk boots, axes, and crosscut saws, all of which were necessary to maneuver and fell trees that were sometimes more than 300 feet tall. For nearly 100 years, wood products were Bandon's chief industry. The work associated with the lumber industry was tough and dangerous, but the demand for high-quality wood products, both at home and abroad, kept men working to reap the seemingly endless resource. (Courtesy Bandon Historical Society.)

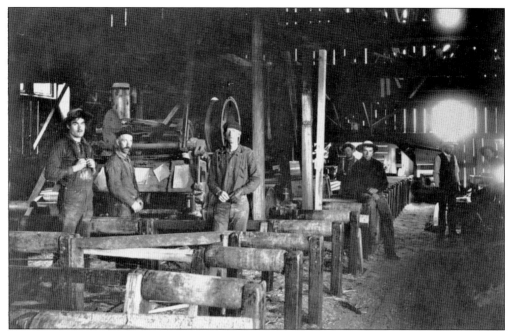

PARKERSBURG SAWMILL, 1897. In 1875, Capt. Judah Parker and Meldon L. Hanscom established the Parkersburg sawmill and shipyard just up the river from Bandon. There was great timber nearby along Seven Mile, Lowe, and Bear Creeks. This sawmill burned down in 1882, but demand was so high that it was immediately rebuilt. (Courtesy Bandon Historical Society.)

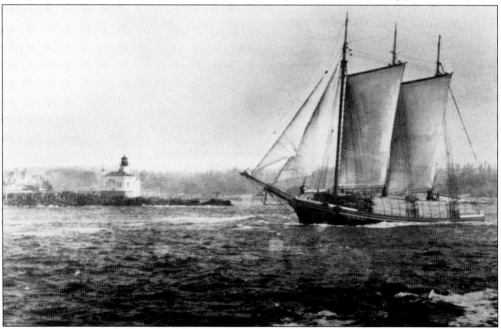

SCHOONER ADVANCE, C. 1910. The three-masted schooner Advance, built in Bandon in 1902, was owned by Capt. Judah Parker, who used it to ship lumber to San Francisco from his sawmill at Parkersburg. The Advance had a carrying capacity of about 400,000 board feet of lumber. (Courtesy Bandon Historical Society.)

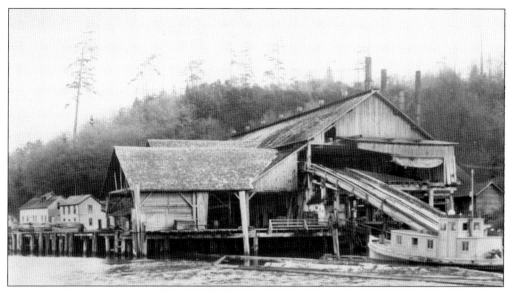

Pershbaker Mill, 1895. Adam Pershbaker moved to Prosper in 1890 and started a sawmill that became one of the major lumber producers on the Coquille River. Prosper was just up the river from Bandon, and the towns were connected by a plank boardwalk. Waste from this mill fueled the boilers that provided Bandon with electricity from 1916 to 1919. (Courtesy Bandon Historical Society.)

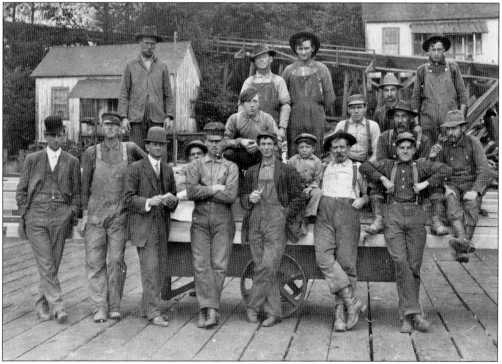

Prosper Residents, 1914. The mill town of Prosper reached its peak between 1910 and 1920. It contained two sawmills, a salmon cannery, a shipyard, grocery and hardware stores, a post office, and a public school, which became a center of social activities. (Courtesy Bandon Historical Society.)

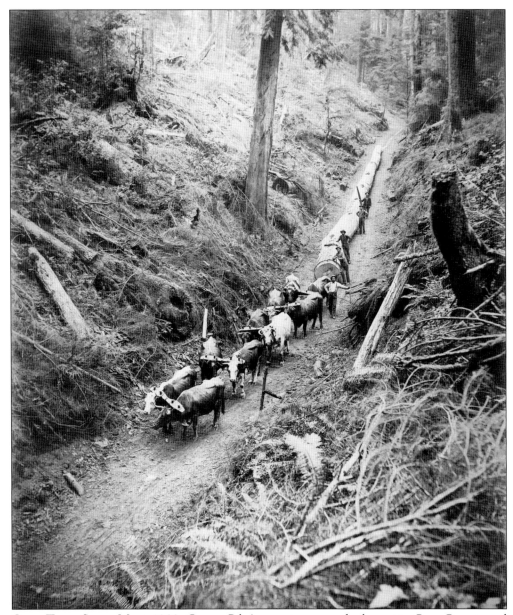

OXEN TEAM, SEVEN MILE, 1902. George Pike's oxen team was the largest in Coos County and provided the power to move logs from the forest to the banks of the Coquille River. Pike provided logs for sawmills at Parkersburg and Prosper. Oxen were more powerful than horses and did not have to be shoed. Each pair of oxen could be counted on to pull about 4,000 pounds. Mechanization displaced oxen teams in the early 1900s. (Courtesy Bandon Historical Society.)

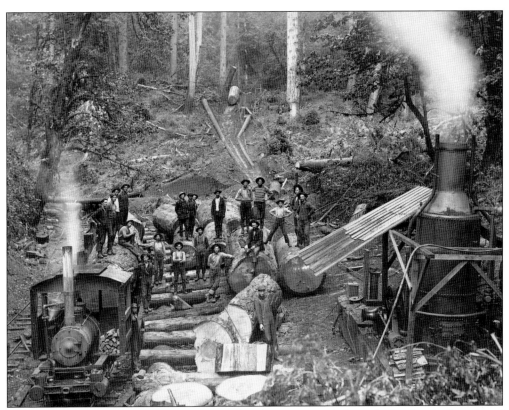

RAILROADS IN THE FOREST. Narrow-gauge railroads were erected along the banks of tributaries of the lower Coquille River to facilitate the transport of logs for the Parker sawmill at Parkersburg, the Pershbaker sawmill at Prosper, and the Cody sawmill at Bandon. Steam-powered winches mounted on log sleds, called "donkeys," pulled logs down to the railroad for transport to the river. Horse-drawn road graders called Fresno Scrapers (pictured below) were sometimes employed to improve access roads. (Both courtesy Bandon Historical Society.)

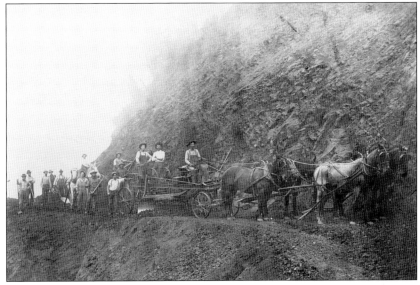

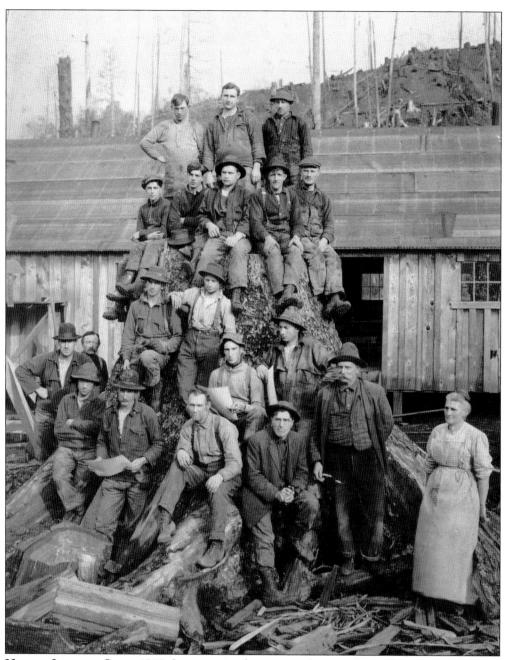

HOWELL LOGGING CAMP, 1913. Loggers pose for a group photograph at a logging camp located a few miles up the Coquille River, near Seven Mile Creek. Bill Howell ran the camp to provide logs for the Prosper sawmill. Howell stands at lower right in this image, next to Mrs. Thomas, the cook. Howell's nephew Harry Hunt is the man wearing a light-colored shirt in the center, leaning on a fellow logger. Brothers John and Elmer McCue (both holding papers) stand to the right of Hunt. (Courtesy Bandon Historical Society.)

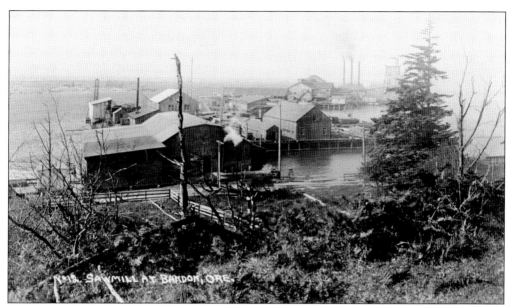

CODY SAWMILL AT BANDON. In 1905, the Cody sawmill was built on the tide flats just upstream of Bandon. L.J. Cody and junior partners M.J. McKenna and George W. Moore were Minnesota timbermen who moved west to take advantage of untapped forest resources along the Coquille River. The Cody sawmill was completely destroyed by fire in 1909. The Acme Planing Mill is in the foreground. (Courtesy Bandon Historical Society.)

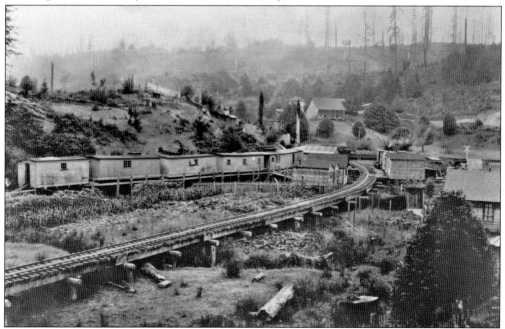

LAMPA LOGGING CAMP, 1905. L.J. Cody moved to Bandon in 1905 and purchased about 5,000 acres of timberland along Lampa Creek, a tributary of the Coquille River located about seven miles east of town. According to local newspaper reports, this camp provided access to over 400 million board feet of timber. The Lampa camp was later a primary source of timber for Moore Mill, along with holdings at Leneve, near Beaver Slough. (Courtesy Bandon Historical Society.)

ORIGIN OF MOORE MILL. After the Cody sawmill burned down in 1909, the concern was reorganized as the George W. Moore Lumber Company. Several years of hard work and unfavorable conditions followed, and the mill was forced to close in 1914. The mill reopened in 1916, and the company was reorganized as the Moore Mill & Lumber Company. George W. Moore (left) eventually passed the responsibilities to his four sons—Ralph, George Jr., John, and Carl. In 1945, the Moore family sold the firm to D.H. Miller Sr., a respected timber operator, and William J. Sweet, president of the Bank of Bandon. Miller bought out Sweet in 1948. In the image below, M.J. McKenna (center), secretary-treasurer of the Moore Mill & Lumber Company, poses with two Moore sons. (Both courtesy Bandon Historical Society.)

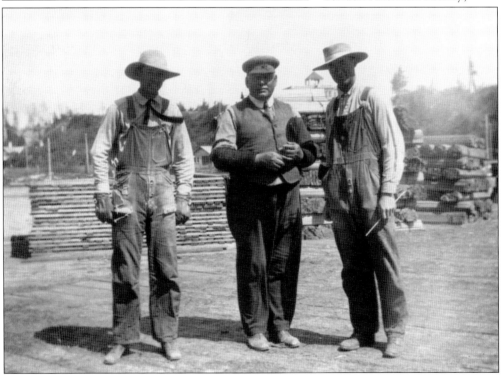

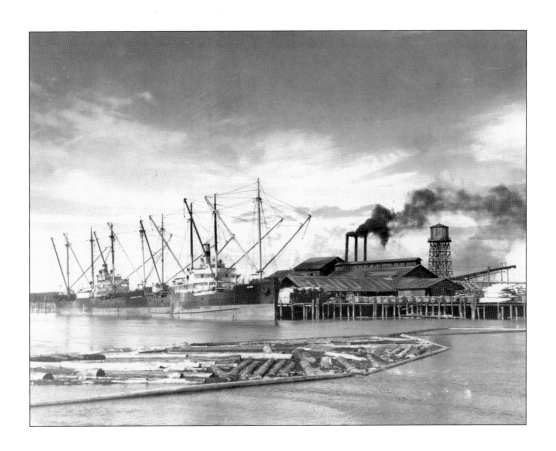

MOORE MILL IN THE 1950s. After World War II, Moore Mill & Lumber Company shipped lumber on boats owned by the Oliver J. Olson & Co. steamship company, including the *Astoria* (front) and the *Barbara Olson* (rear). Another ship, the *Oliver Olson*, ran aground on the Bandon bar in 1953, and the hull was used to extend the south jetty. Log booms, as seen in the foreground of the above photograph, were a common sight on both sides of the Coquille River. In the 1950s, most of Bandon's male residents were employed at the Moore mill, which had several hundred workers on three daily shifts. (Both courtesy Bandon Historical Society.)

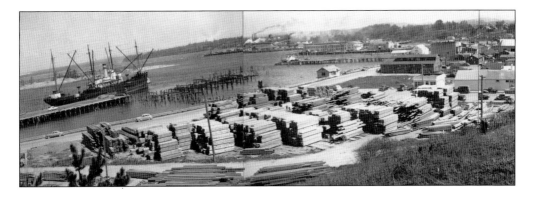

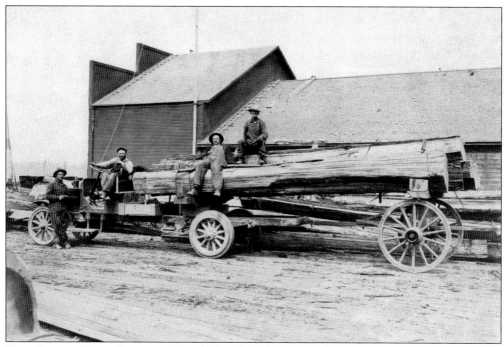

PORT ORFORD CEDAR LOGS, C. 1930. Although cedar is not a dominant species in coastal forests, it has always been valuable to loggers. In the 19th and early-20th centuries, it was valued for shipbuilding; in the 1930s, it was in demand for battery separators and boxes; after World War II, it became sought after for Japanese interior paneling. (Courtesy Bandon Historical Society.)

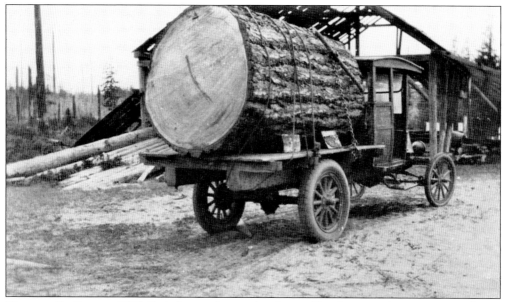

DOUGLAS FIR LOG, C. 1925. Early log trucks were barely capable of moving the massive trees being harvested by loggers. At the time, building roads meant laying logs parallel to each other along stream bottoms to construct puncheon or corduroy tracks. (Courtesy Bandon Historical Society.)

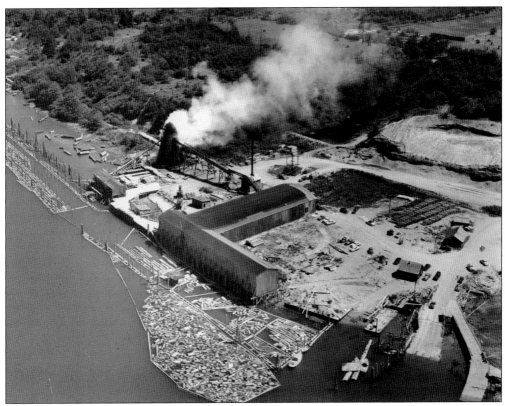

ROGGE AND BARGING. Kenneth Rogge moved to Bandon in 1952 and reopened the old Dollar sawmill just upstream from Bullards Bridge. His mill was a major producer of plywood and planed lumber. The above image shows an extensive log boom along the river and a "wigwam" burner disposing of waste wood. Sause Bros. sent efficient barges upriver to load lumber and plywood for the California market as it grew in the 1950s and 1960s. Several barges were lost at the mouth of the river, as shown below. (Both courtesy Bandon Historical Society.)

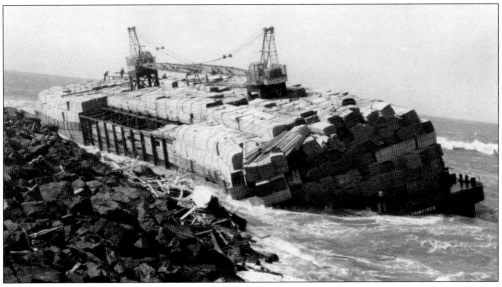

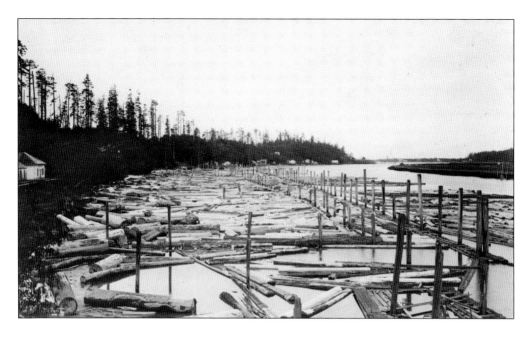

THE RIVER'S LEGACY. For over 150 years, lumber manufacturers have used the Coquille River to transport and store logs. The 1920s photograph above shows log booms in the Prosper area. Water has always been the easiest way to move logs. Today, the Coquille River is lined with pilings that offer mute testimony to the historic importance of logging in the region. The steamers, ships, barges, and schooners (such as the one shown in the 1907 postcard below) that have traveled along the Coquille River are also of lasting importance. (Above, courtesy Bandon Historical Society; below, courtesy Brian Vick.)

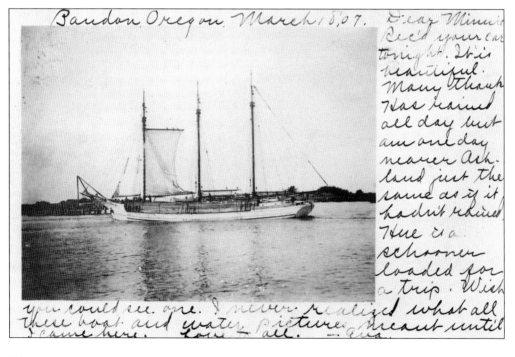

Seven
CRANBERRIES

BANDON CRANBERRIES. Oregon's cranberries have long been prized for their brilliant red color and high sugar content, and cranberry production is well-suited to Bandon's equable climate and acidic, sandy soils. The original market was for fresh fruit and canned sauces for the holiday season, but today, about 90 percent of the crop is marketed as juice. This 1937 photograph is from the St. Sure/Jackson Farms. (Courtesy Jim Jackson.)

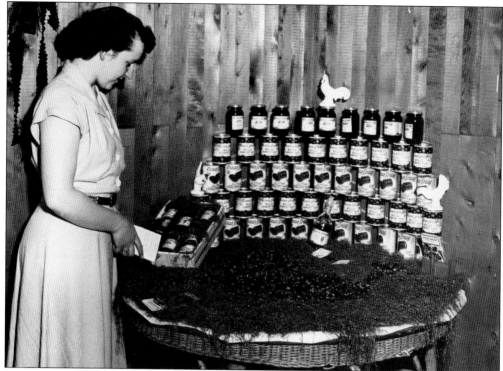

OREGON AND OCEAN SPRAY. About 2,000 acres of land in the state, most of it in coastal southwestern Oregon, are devoted to cranberry production. Oregon produces about six percent of the cranberries in the United States, an output behind only Wisconsin, Massachusetts, and New Jersey. Ocean Spray, a grower-owned cooperative, dominates the market, but almost half of the Bandon-area growers are "independents" that sell to a variety of companies. This c. 1960 image shows Vivian Kranick with an Ocean Spray display. (Courtesy Coos Historical & Maritime Museum 973-90b.)

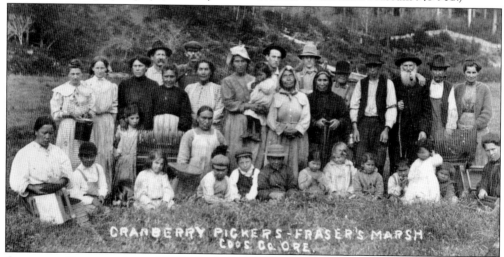

CRANBERRY PIONEERS. Around 1885, Charles McFarlin planted the first cranberries in Coos County using a variety he developed in Massachusetts from wild vines. McFarlin hired members of the Coos and Coquille Indian tribes to help with the harvest. Today, the Coquille Indian Tribe is a major producer of organic cranberries. (Courtesy Coos Historical & Maritime Museum 992-8-3156)

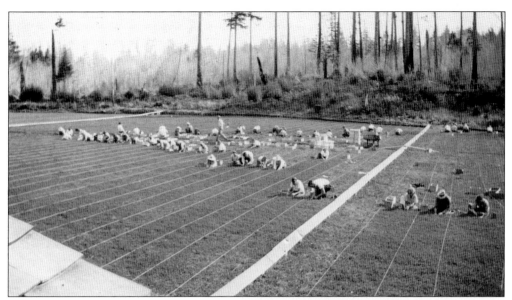

HANDPICKING CROPS, 1937. Picking by hand is the most labor-intensive method of harvesting cranberries. The slow, hard work had to begin in mid-September to be completed before the November winter storms. Pickers were assigned rows and typically engaged in friendly competition. At a pay rate of 10¢ per box, a good picker could make $1 per day. The photograph above shows pickers at St. Sure/Jackson Farms. (Courtesy Jim Jackson.)

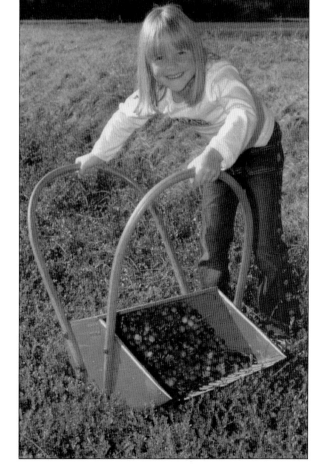

WOODEN SCOOPS. Handpicking was gradually replaced by the use of wooden scoops, which speeded up the harvest. Harvesters utilized a wide variety of scoops ranging from small scoops for women and children to long-handled Wisconsin scoops for tall men. In the 2006 image at right, Hannah Tomasini poses with a small scoop. (Courtesy Reg Pullen.)

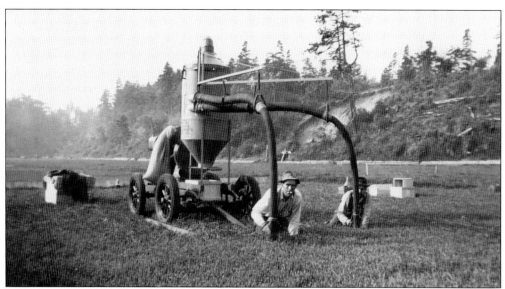

VACUUM PICKING. Growers were constantly striving to find more efficient methods of harvesting. Short harvesting seasons placed a premium on speed, but recovery of the maximum amount of fruit was also important. Vacuum pickers, such as the one shown here on the Kranick farm around 1960, ruined more fruit than they saved and were soon abandoned. (Courtesy Bandon Historical Society.)

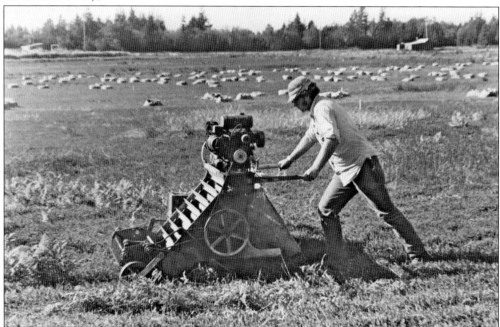

FIRST MECHANICAL PICKER. The Oregon-based Stankavich brothers—Joseph, Michael, and Matthew—developed the first mechanical picker in the United States. This method greatly speeded up harvest on dry land. The mechanical picker is still in use today because of the high value of fresh fruit, but its liabilities include the great strength required to control the machine, the high percentage of lost fruit, and incidental damage to vines during harvesting. (Courtesy Bandon Historical Society.)

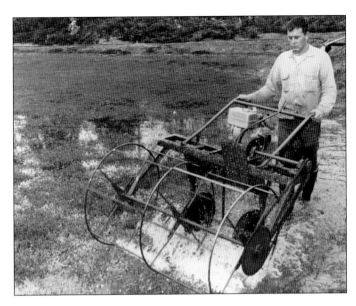

WET HARVESTING. In the 1960s, demand for cranberries expanded as fruit juice became an important part of the market. New techniques were needed to rapidly harvest the crops. Cranberries float, so one solution was to grow them in bogs and flood the bogs at harvest time. Mechanical beaters efficiently knocked the berries off the vines, but at the price of bruising them in the process. Here, Fred Richert harvests cranberries with a beater. (Courtesy Bandon Historical Society.)

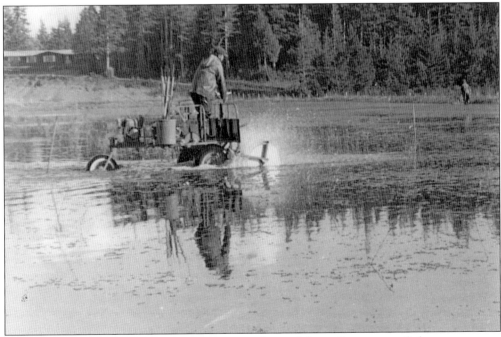

TOP-RIDING MECHANICAL BEATER. Growers soon learned that riding on top of a beater was more efficient than walking behind it. Growers modified beaters to suit their farm's needs, and beaters became bigger, faster, and more efficient. A two-acre bog could be harvested in a few hours with very little lost fruit. Harold Russell, a longtime Oregon member of the Ocean Spray board of directors, harvests cranberries in this c. 1970 photograph. (Courtesy Bandon Historical Society.)

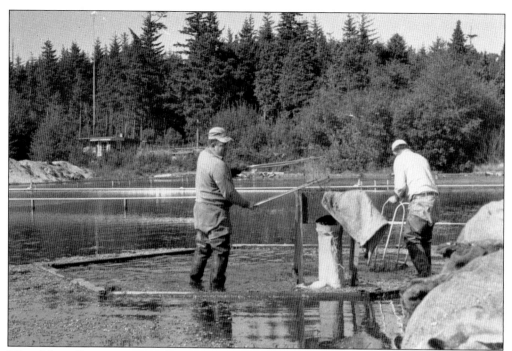

WIRE-MESH SKIMMING. Initially, water-harvested cranberries were skimmed with wire-mesh scoops and deposited into containers. This labor-intensive technique was soon replaced with more efficient methods. Here, Bill (left) and Ray Bates skim for cranberries. (Courtesy Coos Historical & Maritime Museum 986-N799b.)

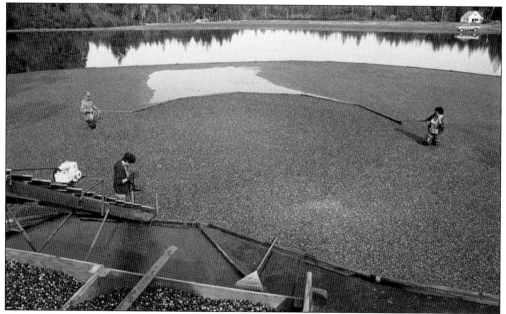

CEDAR CORRALS. After the cranberries have been dislodged from the vines, they are rounded up with booms and corralled at the edge of the bog. The process is seen here on the Pullen farm in 1983. The earliest booms were manufactured from cedar boards and had to be constantly tightened as the fruit was removed from the bog. (Courtesy Reg Pullen.)

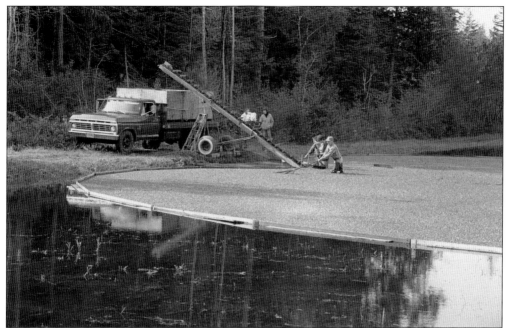

CONVEYOR LOADING. This 1983 image from Spring Creek Farms shows workers loading cranberries into wooden boxes via conveyor. Each box can hold around 700 pounds of cranberries. Trucks, which hold about six boxes, could usually be loaded within an hour. Farms needed to assemble a large crew to boom the berries and feed and clean the conveyor. (Courtesy Reg Pullen.)

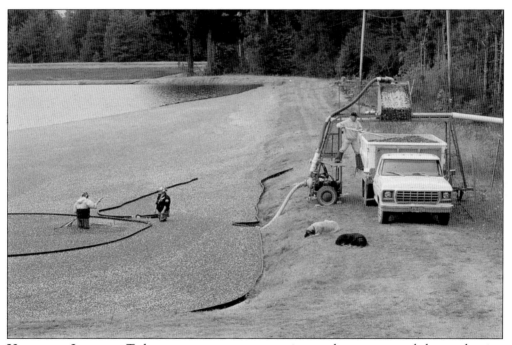

HYDRAULIC LOADING. Today, many growers use containment booms to corral the cranberries, as seen here on the Pullen farm in 2011. The trucks are loaded using hydraulic fruit pumps. The need for labor is reduced, and the fruit is cleaner. (Courtesy Reg Pullen.)

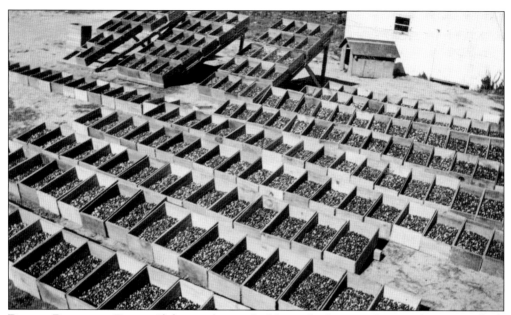

DRYING BERRIES IN BOXES. If the cranberries had been dry harvested in conditions in which the field was wet from rain, the berries could be left in the sun to dry. (Courtesy Bandon Historical Society.)

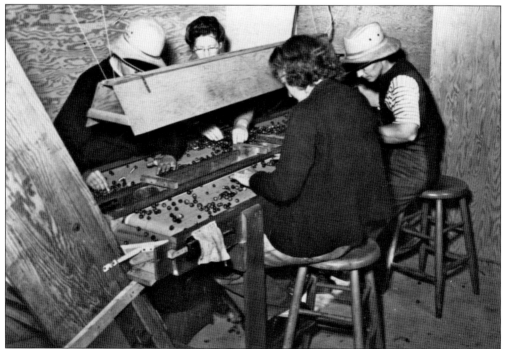

CLEANING STATION FELLOWSHIP, C. 1950. From 1940 to about 1970, dozens of women acquired jobs cleaning dirt and debris from cranberries in the fall. They were typically paid in tokens, which could be exchanged at the local M&L Grocery for goods during the winter. Besides helping to provide for families at a time when many men only worked during the summer (as loggers), the cleaning work offered an opportunity for camaraderie. (Courtesy Bandon Historical Society.)

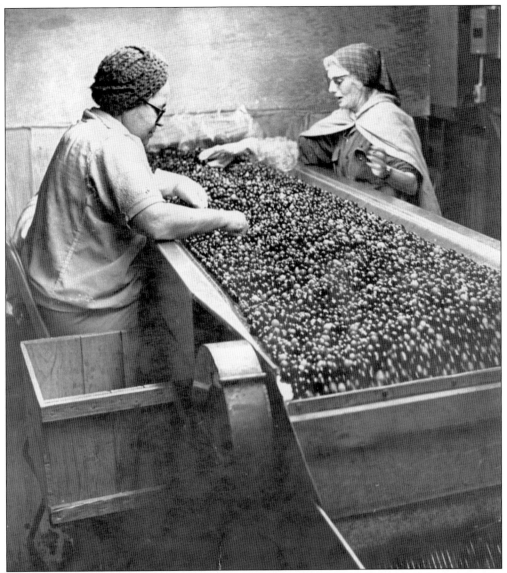

THE HAYDEN SEPARATOR. The Hayden Separator, patented in 1905, sorts good and rotten berries by measuring their bounce. Berries that had sufficient bounce were passed through a conveyor belt, and workers visually checked for other unacceptable berries. This c. 1960 image shows Inez Porter (left) and Ruth Thomas sorting cranberries. (Courtesy Bandon Historical Society.)

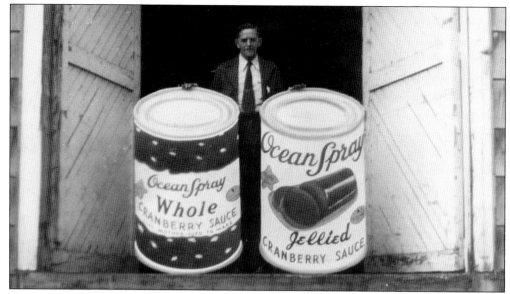

MARKETING OCEAN SPRAY. Through the 1960s, almost all of the national cranberry crop was marketed as either fresh fruit or sauce. Ocean Spray became a household name and was especially in demand at Thanksgiving and Christmas. Ocean Spray's marketing helped stabilize the market, and this benefited all cranberry growers. (Courtesy Coos Historical & Maritime Museum 973-90q.)

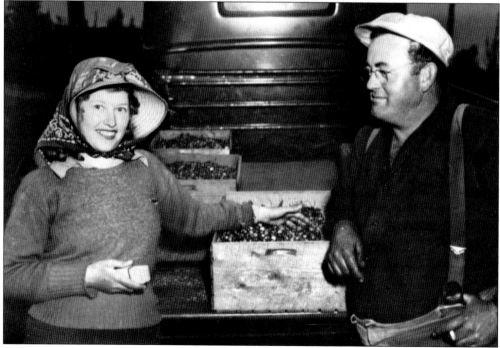

A FAMILY BUSINESS. Many cranberry growers chose to harvest, clean, and market their own crops in the early years before Ocean Spray. Cleaned berries were packed in cedar boxes with colorful family labels and trucked to markets in San Francisco and Los Angeles during the holiday season. This c. 1950 image shows Dorothy Wilson and her husband, Ray. (Courtesy Bandon Historical Society.)

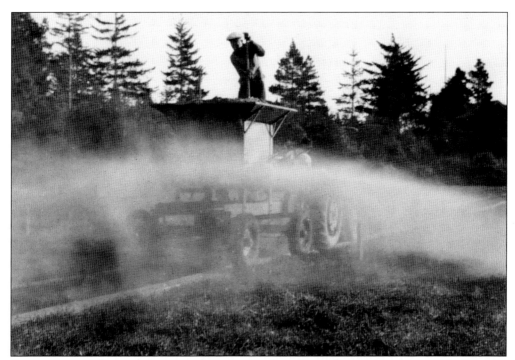

RESANDING THE BOGS. After a cranberry bog is planted, it will remain productive for 20 to 40 years. However, over time, a layer of duff, which harbors insects and diseases, develops under the vines. Adding a few inches of sand atop the vines in a bog, as shown in this c. 1950 photograph, can often restore its vitality. (Courtesy Bandon Historical Society.)

BOG SHOES, C. 1960. Growers needed to spend a lot of the time hand-weeding and fertilizing in the bog. As fruit began to form on the vine in late spring, growers wore bog shoes to avoid crushing the tender berries underfoot. Today, most of these activities are mechanized. (Courtesy Bandon Historical Society.)

DEVELOPING NEW STRAINS, C. 1950. Many growers have attempted to develop new strains of cranberries through cross-pollination. In this photograph, Bandon resident Ray Bates, a pioneer in this effort, is showing off a new cultivar. The original McFarlin variety brought from Massachusetts in 1885 produced about 100 barrels (10,000 pounds) per acre. The efforts of Bates and others led to the development of the so-called Stevens hybrid, which produces about 250 barrels (25,000 pounds) of high-quality fruit per acre. Bandon-area growers have proven to be resilient market participants and are likely to be leaders in producing vibrant, healthy cranberries for years to come. (Courtesy Bandon Historical Society.)

Eight
Dairy and Cheese

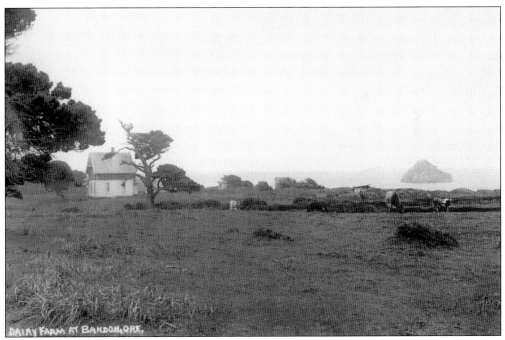

Dairy near Face Rock. Cheese production has a prominent place in the history of southwestern Oregon. Dairy farms and cheese production began in the Coquille Valley around 1880. At the beginning of the 20th century, there were 15 small cheese producers in Coos and northern Curry Counties. By the 1950s, there were about 185 dairy farms in the region. (Courtesy Bandon Historical Society.)

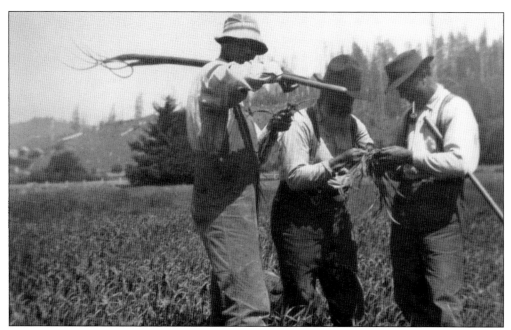

A FERTILE LAND. Early reports, such as this one from the *Coos Bay Times* of January 30, 1930, waxed rhapsodic about the agricultural merits of the region: "Bordering upon limpid inlets, and along streams tumbling seaward from the heart of the Oregon, are fertile valleys smiling with farms, homes where, in the gathering dusk, the tinkle of the cow bell mingles lyrically with the Bob White's [sic] call; and fertile is the soil, a rich alluvial. Green all the year are the meadowlands; moist, without irrigation, the earth beneath, for the rains come here, in winter and spring, in summer and in fall, when rains are needed. . . . Perfect is the climate, no freezing, no excessive heat, and luxuriant the resulting growth." Above, the Haga family farms near Bandon; below is an image from the Barnekoff ranch near Table Rock. (Both courtesy Bandon Historical Society.)

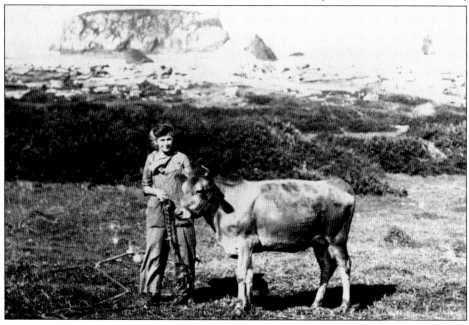

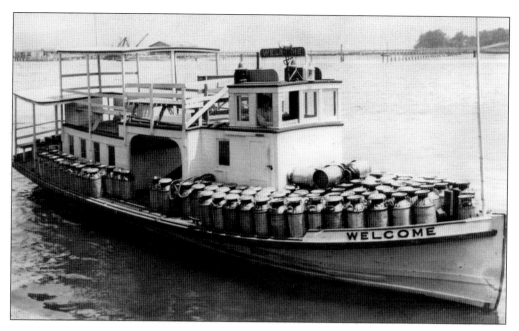

RIVER TRANSPORTATION FOR DAIRY PRODUCTS. Before the existence of usable roads, the river was a fast and largely reliable way for picking up milk at dairies and delivering the cans to condenseries and cheese factories. The *Welcome* of Coos Bay (above) is representative of the dairy vessels that ran on the Coquille River. Below, the steam propeller *Reta* (built by A.R. Ellingson in 1889) hauled milk to the Norway Creamery and supplies to the farmers between Myrtle Point and Coquille. Milk was often transported in five- or ten-gallon cans and was sometimes decanted into one-gallon containers at stops along the way. (Both courtesy Bandon Historical Society.)

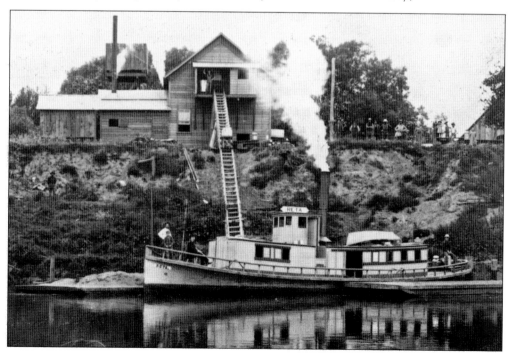

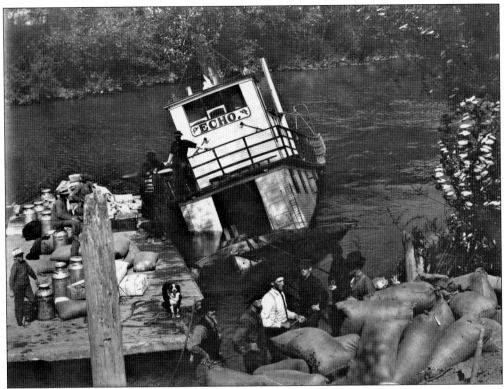

LAND TRANSPORTATION FOR DAIRY PRODUCTS. River transportation was not without its mishaps. Wheelbarrows, hand-drawn carts, and horse-drawn spring wagons were also used to transport milk cans. Above, the *Echo*, built by A.R. Ellingson in 1901, served her entire career on the Coquille River until being abandoned in 1911. Below is a scene from the Parkersburg cheese plant, which was just up the river from Bandon. (Both courtesy Bandon Historical Society.)

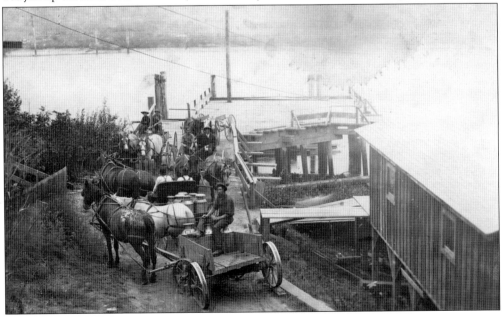

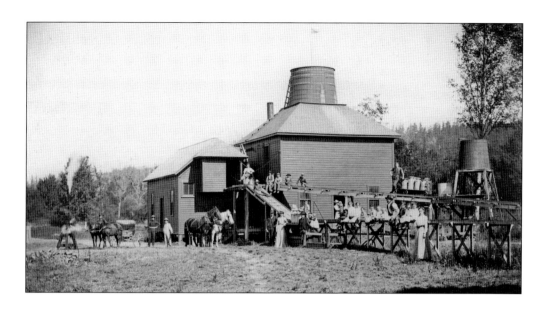

EARLY CREAMERIES IN COOS COUNTY. In 1915, a reporter from *Orchard and Farm* magazine described Coos County as "a sort of cow heaven" on the Oregon coast. The abundant rainfall and mild, cool winters meant fine pastureland and, hence, plenty of milk. Milk could spoil easily, especially in the days before refrigeration, so churning the surplus milk into butter or making it into cheese was one nutritious and economical solution. Farmers' cooperatives formed to provide members with an efficient and profitable means of producing butter and cheese. These images show creameries near Arago (above), and Norway (below), off the Coquille River. (Both courtesy Bandon Historical Society.)

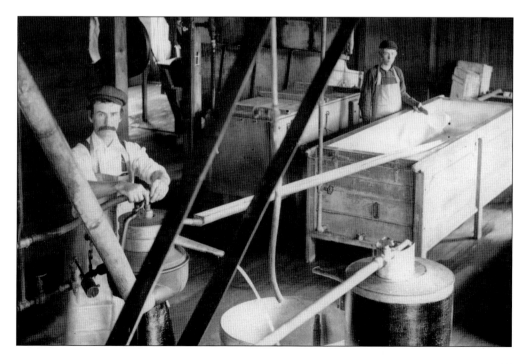

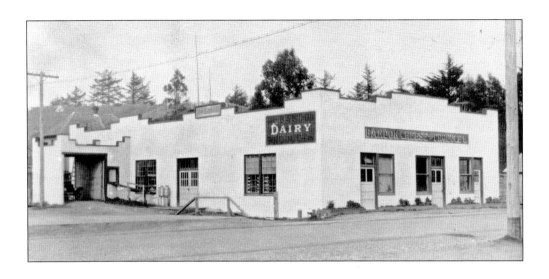

THE FOUNDING OF BANDON CHEESE AND PRODUCE COMPANY. The original Bandon Cheese and Produce Company (aka Bandon's Cheese) was founded in 1927 and sent its first shipment of cheese to California that year. The plant was destroyed in the fire of 1936, but a new plant was built the following year and opened on January 16, 1937. In 1939, local dairy farmers formed the Coquille Valley Dairy Cooperative, which expanded the plant in 1957. Tillamook Cheese acquired the plant in 2000 and shortly thereafter terminated processing and demolished the plant. The handmade cheese of Bandon, Oregon, was regarded as a work of art and was loved by locals and visitors alike. The images on the following five pages are all from the Bandon's Cheese plant. (Above, courtesy Bandon Historical Society; below, courtesy Brian Vick.)

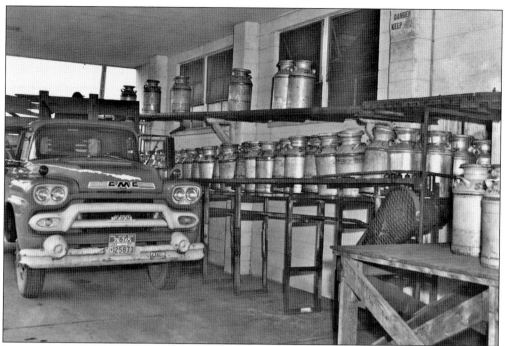

BANDON'S CHEESE PLANT. At its peak, the Bandon's Cheese plant received about 9,000 gallons of milk each day and manufactured 175,000 pounds of butter and two million pounds of cheese each year. The cheese maker's day started at dawn. Milk was kept at the plant overnight in a large holding tank set at 38 degrees. The milk was then pumped through a pasteurizer, where it was heated to 163 degrees for 15 seconds. In the image below, Leroy Nelson (left) and Renzal Stearns ensure a uniform creamy quality in the milk. (Both courtesy Bandon Historical Society.)

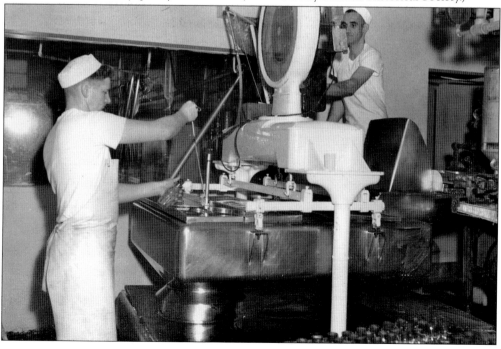

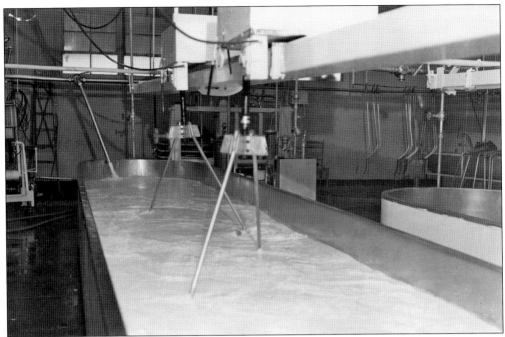

Rennet Coagulates the Milk. Once standardized, the milk is pumped into 2,200-gallon open vats. The milk in each vat weighs about 20,000 pounds. When the vats are half full, a starter culture is added to begin fermentation. The culture begins the settlement of the cheese. In the image below, Leroy Nelson adds rennet, an enzyme, to coagulate the milk; after rennet is added, the mixture is stirred with steel paddles for four minutes to ensure an even consistency. (Both courtesy Bandon Historical Society.)

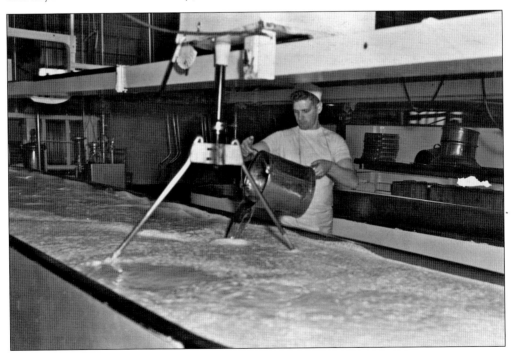

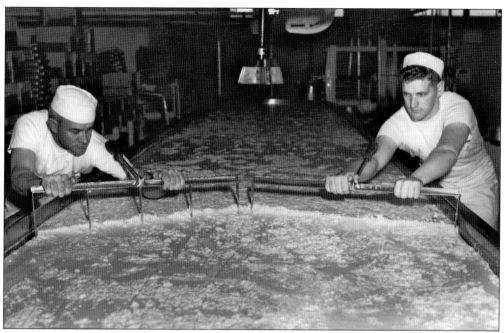

Curds and Whey. In 20 to 30 minutes, the contents of the vat thicken into a custard-like consistency. Wire knife "harps" are used to cut the coagulated content of the vat into curds, and the mixture is paddled to help separate the curds from the whey. The vats are heated, and the curds and whey are cooked for about 30 minutes. Once cooked, the curds and whey are pumped to a large table and paddled again. A ditch formed in the center of the vat allows most of the whey to drain. The cheese makers pictured above are Bob Propeck (left) and Leroy Nelson; below are Renzal Stearns (left) and Bob Howard. (Both courtesy Bandon Historical Society.)

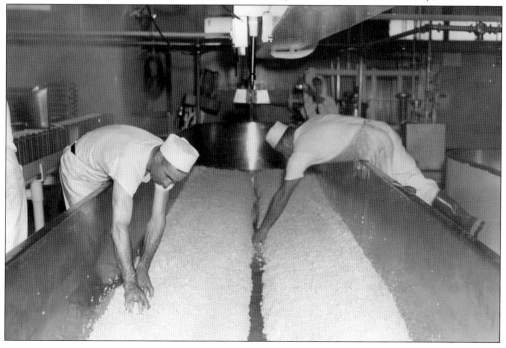

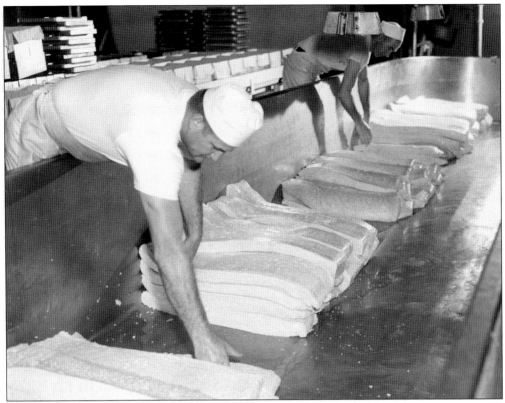

CHEDDARING THE CURDS. The curd, which has now matted into a solid mass, is cut into soft slabs. The slabs are folded and stacked several times until a correct acidity has been reached. This slabbing and stacking process is called "cheddaring" and is what makes cheddar cheese unique in texture and flavor. When the acid has reached the proper level, the slabs are milled, to be cut into curds again. Salt is added to arrest the acid development, and this also helps to create the unique taste of cheddar cheese. (Both courtesy Bandon Historical Society.)

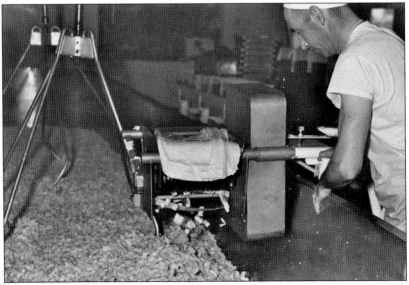

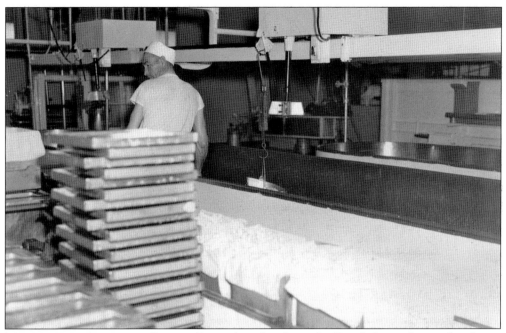

MOLDING AND AGING THE CHEESE. Excess liquid is drained off, and the curds are placed into 40-pound hoop molds to be pressed overnight. The compressed cheese is then bundled in an airtight wrapper of vacuum-sealed paraffin and placed in cold storage. Fresh cheddar cheese is somewhat bland; aging allows the flavor to improve and increases the sharpness of the cheese. Mild cheese is aged for two or three months, medium for three to six months, and sharp cheddar cheese is aged for one year or longer. These images show cheese makers Renzal Stearns (above) and Bob Propeck (below). (Both courtesy Bandon Historical Society.)

FACE ROCK CREAMERY. In 2012, the city of Bandon and local developers Greg Drobot and Daniel Graham confirmed plans to open a new handmade cheese factory on the former Bandon's Cheese site. The new operation is named the Face Rock Creamery after one of Bandon's most distinctive offshore rock features, which is pictured above. (Courtesy Brian Vick.)

SINKO CHEESE MAKERS. Joe Sinko (left) was a longtime owner and operator of the original Bandon's Cheese plant. He is pictured with his son Brad, who was the last general manager of Bandon's Cheese before Tillamook Cheese closed the Bandon plant in 2002. Brad subsequently became head cheese maker for the highly regarded Beecher's Handmade Cheese of Seattle and New York. In 2012, Brad agreed to return as head cheese maker for Bandon's new Face Rock Creamery. (Courtesy Beecher's Handmade Cheese.)

Nine
RECREATION, ATTRACTIONS, AND CELEBRATION

CELEBRATING THE CRANBERRY. Lively industry and inviting recreation made Bandon an appealing place to live and vacation. From camping trips to luxury spa excursions, visitors and residents make the most of Bandon's recreational attractions. Many celebrations inaugurated in the early 20th century continue today. Margaret Olson Carver (left) and her brother Pat Olson are the crowned children in this c. 1950 image from the Bandon Cranberry Festival. (Courtesy Coos Historical & Maritime Museum 995-1.81123.)

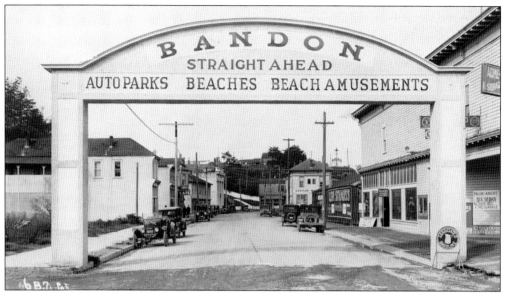

WELCOME TO BANDON. Even before European settlers came to the area, the south bank of the Coquille River was a hot spot for settlement and trade. Bandon's Old Town welcome arches, visible from present-day Highway 101, have been renovated several times. In 1928, this sign welcomed visitors to Bandon's business district with an invitation to enjoy beach amusements. (Courtesy Bandon Historical Society.)

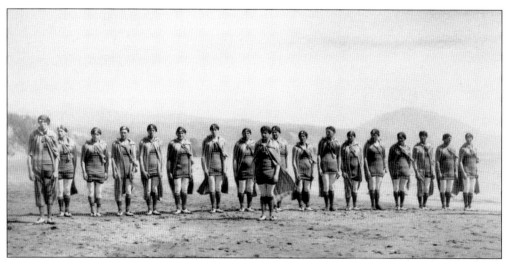

SONS OF BEACHES. In 1925, some members of the Bandon Chamber of Commerce formed the Bandon Beachmen—aka the Boosting Sons of Bandon Beaches—to help promote the city. On March 19, 1925, the *Western World* reported that the group's attire "provokes the assault of eyes of all color and the tender solicitude of every sympathetic beholder who ever nursed a pair of sunburned legs." (Courtesy Bandon Historical Society.)

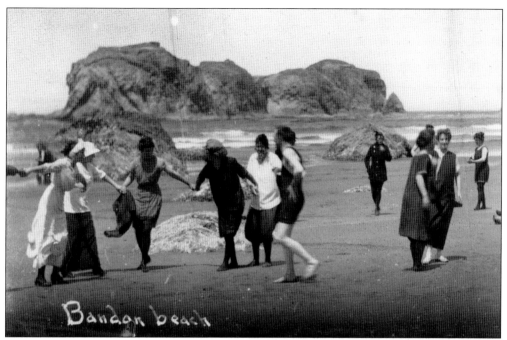

"YOU'LL LIKE BANDON BEACH." The Bandon Natatorium at the Wecoma Baths was one of several saltwater swimming spots on the coast. This natatorium promised bathers a healthy soak in water pumped from the ocean and heated for comfort. The Bandon Natatorium, which was located at Coquille Point, housed several pools and an observation gallery; it burned down in 1936. In the early-1900s image above, youthful guests wear bathing costumes. (Both courtesy Bandon Historical Society.)

Take a Swim -- in Heated Ocean Water

Wecoma Baths and Cottages
BANDON - BY - THE - SEA

The ideal place for Healthful, Invigorating Exercise

NATATORIUM HOURS:

WEEK DAYS—
1:00 p. m. to 5:00 p. m.
7:00 p. m. to 9:30 p. m.

SUNDAYS—
11:00 a. m. to 9:30 p. m.

Eleven Modern Furnished Cottages

Each with Ocean View

Located within easy reach of stores, markets, and all the accommodations of a modern little city, and right in the heart of the beach colony.

J. F. KRONENBERG, Proprietor

Bring Your Golf Clubs and Play at the Westmost Links

"The Westmost Golf Links in the United States" Five minutes from our cottages. You'll Like Bandon Beach

109

A Ride on the Water. Until the 1930s, a day on the town was sure to include a boat ride, since water vessels were the most expedient and reliable form of transportation to and from Bandon. In 1904, the SS *Elizabeth* made its maiden voyage from San Francisco to Bandon carrying freight and passengers. The journey took 42 hours. Paddleboats on the river competed for passengers, and sometimes fistfights broke out between captains. (Left, courtesy Michael Claassen; below, courtesy Bandon Historical Society.)

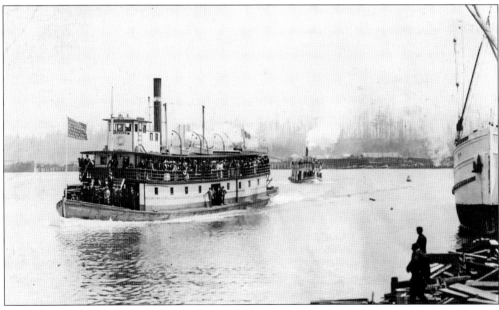

DOWNTOWN PARADES. The waterfront was the beating heart of Bandon, and residents and visitors gravitated there for work and play. Over the years, Bandon residents have organized countless parades and carnivals. The festivities often celebrated the area's industries, including logging, fishing, and farming. In this 1941 photograph, Shirley Langlois leads a parade through downtown. (Courtesy Bandon Historical Society.)

PROFESSIONAL ATHLETES VISIT BANDON. Business owners took advantage of public interest in professional and semiprofessional athletic events. On November 15, 1913, wrestlers Tony Ajax (left) and M.G. Lutsey competed in a match at the Lorenz Store in Bandon. (Courtesy Bandon Historical Society.)

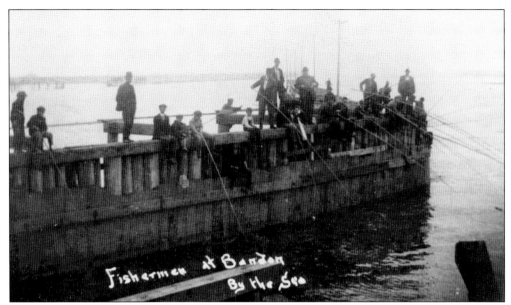

RECREATIONAL FISHING. While commercial fishing was a thriving enterprise, sport fishing also had its place in Bandon. Line fishing from waterfront wharves allowed fishers to socialize while catching supper. People also participated in net and line fishing from boats on the river. (Courtesy Bandon Historical Society.)

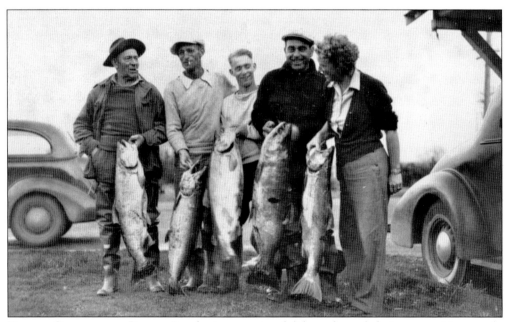

FISHERS COMPETE FOR PRIZES. Bandon's recreational fishers showed their competitive streak. Before filleting their fish, men and women often took time to memorialize the catch of the day in a photograph. In 1949, the Bandon Game and Fish Club organized the Bandon Salmon Derby and offered prizes for the best catch. The contest is now sponsored by the Port of Bandon and the Bandon Bait Shop. (Courtesy Bandon Historical Society.)

RECREATION ATTRACTS TOURISTS. Bandon visitors could find lodging at several hotels and auto courts. The whimsical Natureland was built by John Dornath and Sons. Located off Beach Loop Drive, Natureland featured a windmill and easy access to Bandon beaches; it closed in the 1970s, and only one of the Natureland cottages still stands today. Bandon's largest downtown hotel, the Gallier Hotel, registered more than 9,000 guests in 1912. (Courtesy Bandon Historical Society.)

HARTMAN THEATRE, 1925. The Hartman Theatre was a regular destination for locals. The downtown facility ran feature films and hosted live entertainment such as the Bandon Concert Band (pictured). The band's repertoire included marches such as "Collegian" and "Stars and Stripes Forever." The band also played popular tunes like "You're Just a Flower from an Old Bonnet" and "Kiss Me Goodnight." (Courtesy Bandon Historical Society.)

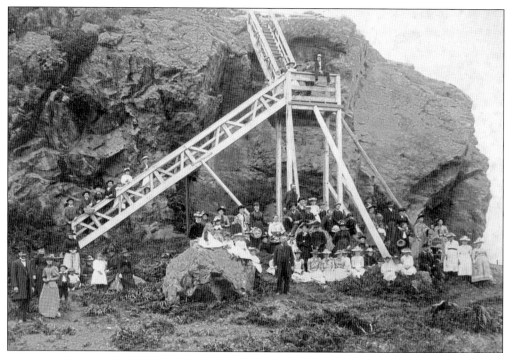

SUNDAY SCHOOL PICNIC FROM COQUILLE. A community or family gathering was a perfect excuse to gather at the beach. As seen in this 1880s image, ladies and gentlemen dressed for a luncheon *en plein air* as they would for an indoor repast—full skirts for women, jackets and ties for men. (Courtesy Bandon Historical Society.)

SOCIAL DISCOURSE AT CHURCH, 1908. Throughout Bandon, congregations celebrated holidays and special events. St. Mary's Catholic Church, erected in 1883, was the first church built in Bandon. The Episcopal church was built in 1889, the Presbyterian church in 1891, and the Methodist church in 1892. In this image, Methodist minister Reverend Myers and a parishioner pose in a festively bedecked sanctuary. (Courtesy Bandon Historical Society.)

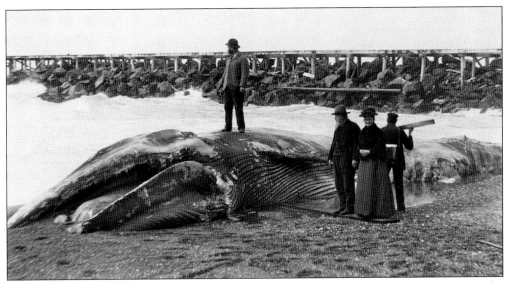

LEISURE PHOTOGRAPHY. The increasing accessibility of cameras and equipment meant more candor and creativity in the resulting images. Unusual events, like a beached whale, were opportunities for an interesting print. Here, William Wrenshall poses on top of a beached whale while Michael and Josephine Breuer stand on the beach with an unidentified US Life-Saving serviceman. (Courtesy Bandon Historical Society.)

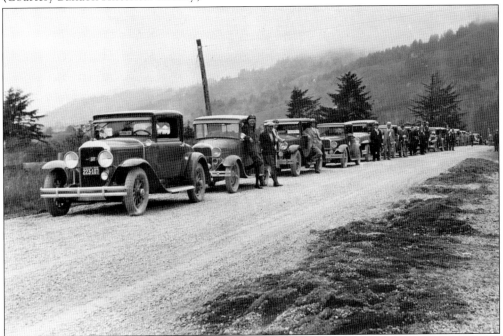

BANDON CHEERS NEW HIGHWAY. Locals flocked to the official opening of Highway 101. Known for years as the Roosevelt Highway, Oregon Coast Highway 101 was funded by the Oregon legislature and the federal government. Highway construction near Bandon occurred between 1923 and 1924, though automobile traffic through Bandon did not significantly increase until bridges were constructed across the Coos and Rogue Rivers in the 1930s. (Courtesy Bandon Historical Society.)

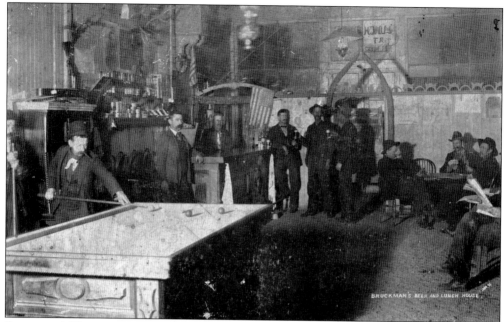

BRUCKMAN'S HOUSE, 1914. Bruckman's Beer and Lunch House was one of several downtown saloons that catered especially to visiting loggers. The influx of timber workers could double Bandon's population on weekends. While the saloons catered to an obvious demand, many residents viewed alcohol sales as a drain on local resources, since drunken disturbances disrupted business and discouraged families from spending weekends in town. (Courtesy Bandon Historical Society.)

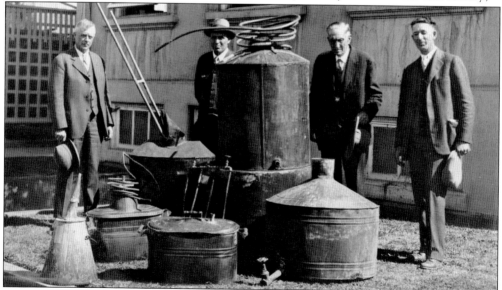

AGENTS BUST BOOTLEGGERS. Oregonians voted for prohibition, and Bandon's saloons closed their doors on December 31, 1915. With alcohol consumption banned, many local families found Bandon a more inviting destination. Through the prohibition years, agents Oakes and Hunt visited Bandon often to aggressively search for moonshine whiskey distilleries, confiscate equipment, and arrest operators. A teenage boy was killed in one such raid at Floras Lake south of Bandon. (Courtesy Bandon Historical Society.)

BUSINESS MEN'S CARNIVAL, 1911. The Queen of the Industrial and Agricultural Fair was crowned by newly elected Oregon governor Oswald West. During her reign, the queen posed for formal portraits and made promotional appearances at community events such as the Business Men's Carnival. In the below photograph, from left to right are Maxine Oaks, Erma Crane, Carol Garfield, Ritte McNair, Dolly Bowman, Gladys Oaks, Edna Gallier (the queen), and an unidentified young lady. (Both courtesy Bandon Historical Society.)

MAY DAY IN THE PARK, 1927. Throughout the 1920s, Bandon City Park was the destination for May Day celebrations that included a maypole, and entertainment provided by Bandon youth. Local schoolteachers outfitted their students in fanciful costumes (complete with props), and children paraded as flowers or chimney sweeps. The park, built east of the bluff at Coquille Point, was inaugurated in the summer of 1912. (Both courtesy Bandon Historical Society.)

RESIDENTS CELEBRATE. As early as 1900, Bandon residents demonstrated their enthusiasm for a good parade. A rainy July 4, 1900, found unpaved streets dotted with mud puddles, but residents still gathered to celebrate with flags waving. As the town grew, merchants and farmers organized events to promote Bandon industries. Below, a horse-drawn carriage float advertises local dairy products in the 1913 White Cedar Carnival. (Above, courtesy Coos Historical & Maritime Museum 987-P35; below, courtesy Bandon Historical Society.)

INAUGURAL BANDON CRANBERRY FESTIVAL. The first annual Bandon Cranberry Festival was organized in the fall of 1947 to coincide with the commencement of the local cranberry harvest. That year, the six Bandon High School students on the first Cranberry Court were, from left to right, (first row) JoAnn Smith, Ruth Kreutzer, and Patricia Whalen; (second row) Virginia Corrie, Jeanette Danielson, and Janet Helm. Kreutzer was crowned Cranberry Queen that year. The festival was a hit, and it is still the community's principal annual celebration. (Courtesy Bandon Historical Society.)

Ten
WORLD-CLASS GOLF COMES TO BANDON

BANDON DUNES GOLF RESORT. Bandon Dunes, the first of five authentic Scottish links courses in the area, opened to critical acclaim in 1999. The wide, rolling fairways, large and undulating greens, prolific heather and gorse vegetation, and breathtaking ocean views have brought an old-world golf experience to Bandon's backyard. In this c. 2000 image, developer Michael Keiser (left) and Howard McKee survey the course. (Courtesy Wood Sabold.)

JOSH LESNIK. Bandon Dunes developer Michael Keiser hired Lesnik (pictured) to serve as the first general manager of Bandon Dunes. His job was to "create something out of nothing." Keiser allowed Lesnik to follow his instincts, and the watchwords for Bandon Dunes became "keep it simple" and "keep it classic." Lesnik, who served as general manager of Bandon Dunes from 1998 to 2000, is now president of KemperSports. (Courtesy Wood Sabold.)

HANK HICKOX. A fourth-generation Oregonian, Hickox is the current general manager of Bandon Dunes. Upon learning that *Golf Digest* magazine had ranked Bandon Dunes as the best golf resort in North America in 2011, Hickox told the *Oregonian* that, "we know that every day you've got to earn your stripes. We're committed to the everyday process of creating fond memories for our customers." (Courtesy Wood Sabold.)

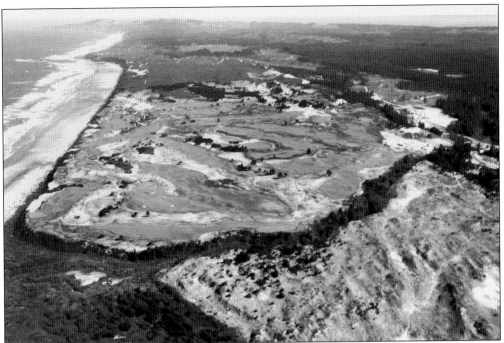

EVOLUTION OF BANDON DUNES. Oregon land use law made for a difficult permit process, but after considerable public involvement and review, a plan was eventually approved in 1997. Remarkable golf course architects—including David McLay Kidd, Tom Doak, Bill Coore and Ben Crenshaw, and Jim Urbina—contributed to the evolution of the resort. Howard McKee, one of developer Michael Keiser's most trusted advisors on the design for Bandon Dunes, is remembered as being affable yet uncompromising in his vision. The c. 1999 image below is the first photograph ever taken of the 12th hole, which was the first hole constructed for the Bandon Dunes Golf Resort. (Both courtesy Wood Sabold.)

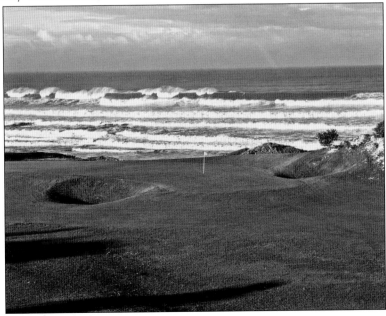

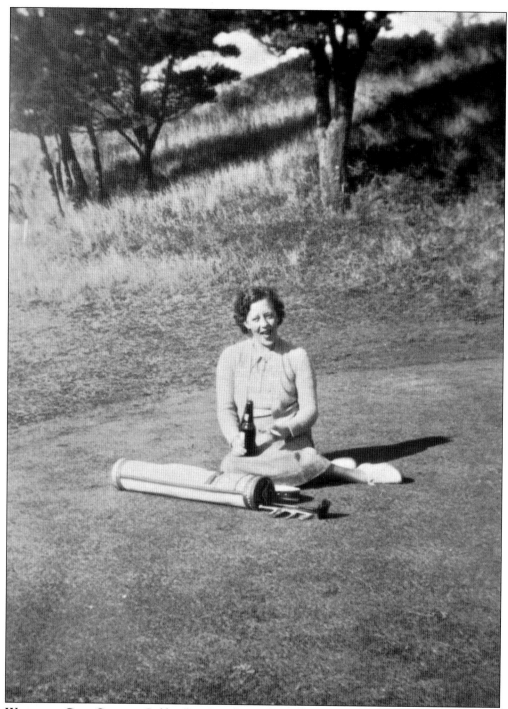

WESTMOST GOLF COURSE. Golf in Bandon, Oregon, had its roots in the Westmost Golf Course located off Beach Loop Drive. This course first opened in October 1927 and has since had various names; it is now known as the Face Rock Golf Course. In this 1934 photograph, Melba McCoy Sullivan engages in three vices ordinarily only enjoyed by the men of her day. (Courtesy Sheila Banks.)

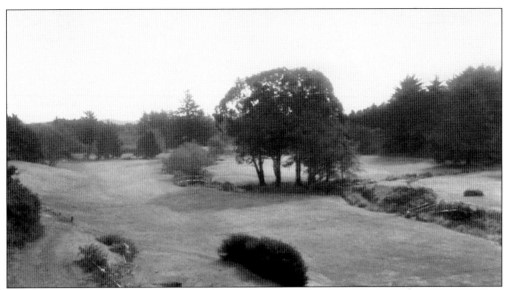

FACE ROCK GOLF COURSE. A meandering stream presents a challenge to nearly every tee shot, and the course's close proximity to town makes it a quick and fun golfing excursion for visitors as well as locals. (Courtesy Troy and Kim Russell.)

REX AND CARLA SMITH. The Smiths, owners and developers of Bandon Crossings Golf Course (not affiliated with Bandon Dunes), state on the course's website that, "We didn't want to make a golf course; the golf course wanted to be made." Bandon Crossings, located south of the City of Bandon, opened to wide critical acclaim in 2007. (Courtesy Rex and Carla Smith.)

BANDON CROSSINGS GOLF COURSE. Bandon Crossings is on the site of a former sheep and cattle ranch. A favorite of visitors and locals alike, the course features an open, parkland-style north nine and a wooded, forest-style south nine, all of which are kept in prime condition. Built on ancient sand dunes, the course has a loamy soil that provides excellent drainage and year-round playability. A round of golf takes the participant across Two Mile Creek, through dense Douglas fir and red-barked madrone forests, and up and down ravines and valleys. (Both courtesy Wood Sabold.)

BIBLIOGRAPHY

Acklin, Carol Tucker, and Ned Reed. *Welcome to Bandon: A Quickread History of the First 150 Years (1850 to 2000)*. Bandon, OR: Ned Reed, Charts, Maps and Graphics, 2005.
Beckham, Dow. *Bandon By-the-Sea: Hope and Perseverance in a Southwestern Oregon Town*. Coos Bay, OR: Arago Books, 1998.
Bennett, George. "A History of Bandon and the Coquille River." *Oregon Historical Quarterly* 28(4) (1987): 311–357.
Coquille Valley Dairy Cooperative. "Cheese Making in the Beautiful Coquille Valley." Bandon, OR.
Goodwin, Stephen. *Dream Golf: The Making of Bandon Dunes (Revised and Expanded)*. Chapel Hill, NC: Algonquin Books, 2010.
Greif, Joan. *Complete Coos Dairy History Yet to be Written*. North Bend, OR: Coos Historical & Maritime Museum, 2008.
Hall, Roberta, ed. *People of the Coquille Estuary: Native Use of Resources on the Oregon Coast: An Investigation of Environmental and Cultural Change in the Bandon Area Employing Ethnology, Human Biology, and Geology*. Corvallis, OR: Words & Pictures Unlimited, 1995.
Hull, Lise. *Coos County*. Mount Pleasant, SC: Arcadia Publishing, 2007.
Ivy, Donald B. and R. Scott Byram, eds. *Changing Landscapes: Sustaining Traditions. Proceedings of the Fifth and Sixth Annual Cultural Preservation Conference, 2001–2002*. North Bend, OR: Coquille Indian Tribe.
Lansing, William A. *Can't You Hear The Whistle Blowin': Logs, Lignite, and Locomotives in Coos County, Oregon, 1850–1930*. North Bend, OR: William A. Lansing, 2007.
Oregon Parks and Recreation Department. "Bullards Beach." Bandon, OR.
Osborne, Ernest L. *Wooden Ships and Master Craftsmen*. Bandon, OR: Bandon Historical Society, 2002.
Peterson, Emil R., and Alfred Powers, eds. *A Century of Coos and Curry*. Bandon, OR: Coos-Curry Pioneer and Historical Association, 1977.
Pinyerd, David. *Lighthouses and Life-Saving on the Oregon Coast*. Mount Pleasant, SC: Arcadia Publishing, 2007.
Proehl, Jim, and Carol Acklin. *Bandon Burns: Survivor Accounts of the 1936 Bandon Fire*. Bandon, OR: Bandon Historical Society, 2012.
Willingham, William F. *Army Engineers and the Development of Oregon: A History of the Portland District U.S. Army Corps of Engineers*. Washington, DC: US Army Corps of Engineers, 1983.
Younker, Jason, Mark A. Tveskov, and David G. Lewis, eds. *Changing Landscapes: Proceedings of the Fourth Annual Coquille Cultural Preservation Conference*. North Bend, OR: Coquille Indian Tribe, 2000.

Discover Thousands of Local History Books Featuring Millions of Vintage Images

Arcadia Publishing, the leading local history publisher in the United States, is committed to making history accessible and meaningful through publishing books that celebrate and preserve the heritage of America's people and places.

Find more books like this at
www.arcadiapublishing.com

Search for your hometown history, your old stomping grounds, and even your favorite sports team.

Consistent with our mission to preserve history on a local level, this book was printed in South Carolina on American-made paper and manufactured entirely in the United States. Products carrying the accredited Forest Stewardship Council (FSC) label are printed on 100 percent FSC-certified paper.